D1369667

GLASS GARDENS

GLASS GARDENS

Easy Terrariums, Aeriums, and Aquariums for Your Home or Office

MELANIE FLORENCE

Skyhorse Publishing

Skyhorse Publishing books may be purchased in bulk at special discounts for sales promotion, corporate gifts, fund-raising, or educational purposes. Special editions can also be created to specifications. For details, contact the Special Sales Department, Skyhorse Publishing, 307 West 36th Street, 11th Floor, New York, NY 10018 or info@ skyhorsepublishing.com.

Skyhorse® and Skyhorse Publishing® are registered trademarks of Skyhorse Publishing, Inc.®, a Delaware corporation.

Visit our website at www.skyhorsepublishing.com.

10 9 8 7 6 5 4 3 2 1

Library of Congress Cataloging-in-Publication Data is available on file.

Cover design by Jane Sheppard
Cover photo credit: iStock

Print ISBN: 978-1-5107-1953-8
Ebook ISBN: 978-1-5107-1954-5

Printed in China

For Josh and Taylor, who are far more creative and artistic than I could ever hope to be.

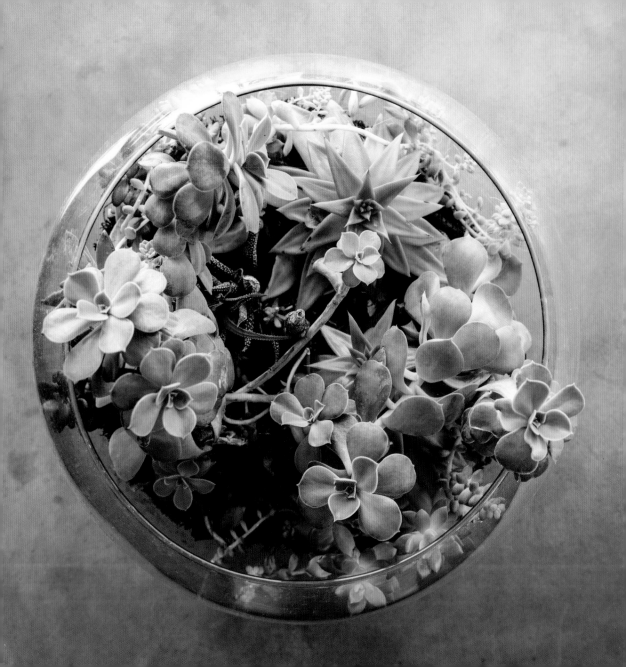

Contents

Introduction 1

Plants to Consider 4

 Tropical House Plants 4

 Succulents 5

 Air Plants 7

 Water Plants 8

Getting Started 13

 Supplies 13

 First Steps 17

 Watering 18

Gardens 21

Popular Plants to Try 119

About the Author 128

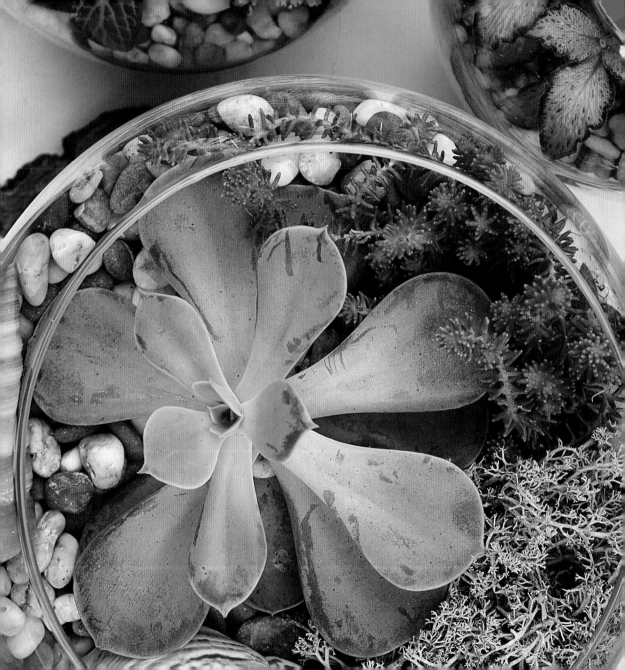

Introduction

Welcome to the amazing world of terrariums!

I imagined myself as kind of a ringmaster when I typed that. Top hat on, arms held wide, maybe a classy and dramatic accent of some kind.

Truthfully, I'm sitting cross-legged in my car, waiting for my kids to get out of school and trying to think of something to say that won't make me sound like a Martha Stewart clone. I'm no domestic goddess, I assure you.

What am I? A mom with a busy writing career who loves to make things. I don't always succeed, but I love to try.

The first time I made a terrarium, I was a Girl Scout. It was one of the activities our Scout leader planned and I fell in love with how beautiful the plants looked—a little garden tucked away behind glass that I could hold in my hands while winter was gearing up around me. We were given some pretty basic supplies and left to our own devices. Mine came out looking a little less than perfect, but that was okay. It was perfect to me. I had made my own terrarium!

Fast forward more years than I care to admit, and I'm browsing for books at the library. I found some stunning books on planters and terrariums but none of them

were as basic and simple as I was looking for. In fact, some of them were so incredibly advanced that there was no way I could hope to recreate their designs. Believe me. I tried.

So when I got the chance to write a book about terrariums, I decided to keep it simple. Instead of talking to you like you're an expert and have a vast understanding of plants, you'll find that I chose a very honest approach—I couldn't even identify some of the plants I used in these projects and struggled my way through many of them, and I'm letting you know it. Rather than bog down the pages with detailed instructions, I give you less information and encourage you to look at the pictures and then make it unique instead of copying them exactly. Instead of trying to sound like I'm a professor of botany, teaching you how to make your own glass gardens, I invite you to make a cup of coffee or tea . . . or maybe pour yourself a glass of wine and get comfortable. For the next hour or so, consider me a friend who is learning as I go.

Just like you.

Terrariums first grew in popularity in the Victorian era and have recently experienced an uptick in popularity once again. Maybe because it's an easy hobby at any age and it doesn't cost a fortune. Historically, terrariums were plants housed in closed glass containers. People planted them because they didn't have the property for real gardens, and unlike real gardens, they required very little work to set up and maintain. Since they were in closed containers, you didn't have to water them because they'd create their own humidity to keep the delicate plants alive. Terrariums were perfect for climates that made gardening difficult and where people wanted to enjoy plants year round.

Today, terrariums have morphed into elaborately designed planters that include figurines and all manner of themes and décor. Some are closed, many are open. What people now often refer to as terrariums are really more like glass gardens.

Over the next few pages, I'm going to walk you through the types of plants you may consider using for your glass gardens, as well as the other materials you may want to gather before you start.

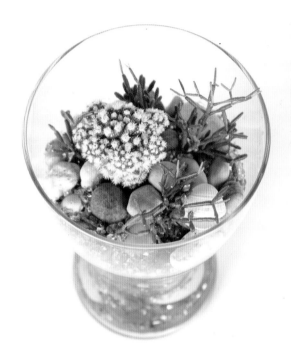

Plants to Consider

TROPICAL HOUSE PLANTS

Tropical house plants are excellent for terrariums! I love terrariums because you can bring the garden inside and keep it year-round, but adding a bit of color with tropical house plants makes them so much more appealing. Some plants are definitely better to use than others. Below, I'll list some of the best tropical plants for your glass gardens.

You'll want easy-to-care-for plants if you don't have the time or inclination to spend a lot of time working with them. If you spend a great deal of time away from home, you should consider a closed terrarium that will keep the humidity higher than an open container and require much less of your attention. Check to see how much light your plants needs, as well. Some plants need more light than others so make sure whichever plants you choose to put together will thrive in the same atmosphere.

Ferns—I've used several kinds of ferns, and they've all been easy to care for and have added a touch of delicacy to my containers. I particularly love my bird's nest ferns. They help clean the air, and they look amazing.

Moss—I have to be honest . . . I've killed moss more times than I care to admit. But club moss is pretty easy to grow and hardier than some of the more delicate versions.

Polka dot plants—I use them a lot. I love the pink color, and they're so incredibly easy to keep alive!

Spider plants—No, they don't have spiders in them. They're trailing plants that you can use in any container.

Bromeliads—Colorful tropical plants. Some look like aloes and some like grasses.

SUCCULENTS

Succulents aren't as easy to care for as air plants, but they're still easier than most house plants. They love sunlight and don't require as much water as your average house plant. They come in all shapes and sizes, so the sky really is the limit for them.

The most frustrating thing about going to a nursery and stocking up on succulents is that in every single place I went, they were simply identified as "succulent." I buy things I think are interesting or will look good planted together . . . but I never really know what they're called (and I'm sure many of you can relate!). I even asked someone what one particular plant was called (a curling vine-y plant) and was told, "It's a succulent." Thanks. I figured.

If you desperately want or need to know what family your plant is from, there are places you can look them up online, and I do encourage you do to so—especially if an allergy (you, your child, or pet!) is involved. Truthfully, I'm always more interested in how my plants look than what their unpronounceable "real" names are.

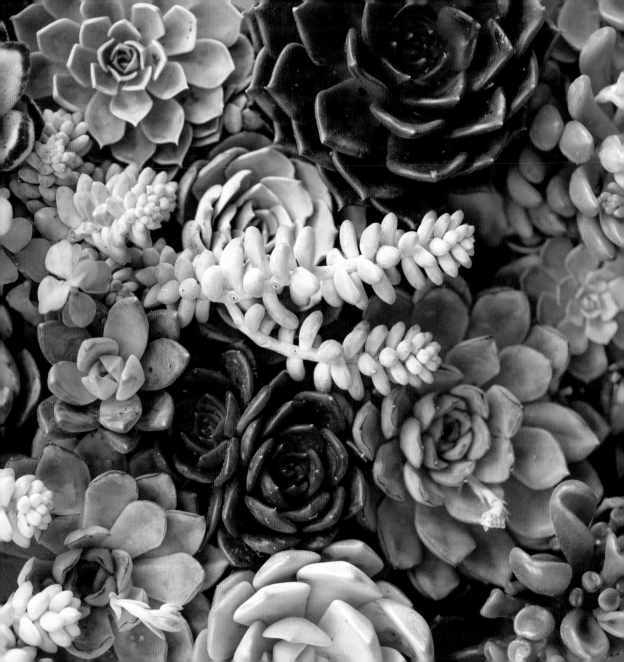

Succulents need about six hours or half a day of full sunlight, so keep them in a sunny place with one caveat: if your window gets too hot, your plants can burn, so I've heard of people keeping their succulent terrariums in east-facing windows instead of south. Use your best judgement and keep an eye on your plants to see how they're doing. Succulents do best when they have some space around them, so keep that in mind when planting.

They also prefer a drier climate so be sure you don't overwater. Glassware is tricky for succulents because the water has nowhere to go, so absolutely *do not overwater*! You don't need to water as often as other plants, but you'll want to get enough water in there to soak the roots and then let the soil dry out. But again, don't overwater.

Have I stressed that enough?

Some of my favorite succulents to work with and that you'll see in this book, are:

- Aloe vera
- Haworthia
- Echeveria
- Aeonium
- Senecio
- Hens and chicks

AIR PLANTS

Air plants are absolutely the easiest to work with and maintain, mostly because you really don't have to do much to them. You don't plant them in soil and you don't have to water consistently like you do with normal plants.

Epiphytes belong to the same family as orchids and are tropical plants that attach themselves to branches, bark, or moss. Air plants have no roots and take moisture from

the air to survive. Because they're tropical, you'd think they'd thrive in direct sunlight, but air plants actually do best in bright but not direct sunlight. So any window that isn't facing south is perfect for them. Temperature isn't as important; they obviously will do best in warmth but can live in temperatures as cold as 32°F (0°C).

I was always under the impression that you didn't need to water air plants at all, but nothing could be further from the truth. It's not enough to just mist them, either, although you can do that once a day. But once a week or so, you should take your air plants and submerge them in plain drinking water for half an hour. If you have an air plant that is blooming, you'll want to rinse it under gently running water instead. After watering, shake them off (again, gently) and leave them to air-dry on a drying rack or towel.

If you take care of your air plants and keep them healthy, you'll notice them multiplying after they bloom. When you see little mini plants growing off the side of your air plant, you'll know it's multiplying. You can separate them carefully once the babies are half as big as the mother plant.

Air plants come in a huge variety of shapes and sizes. Some flower and some don't. You'll find that their possibilities seem endless.

WATER PLANTS

And you thought the air plants were easy to work with? A water terrarium is ideal for anyone who has trouble keeping plants alive or who really doesn't want the responsibility of maintaining a more classic terrarium. Even the super easy air plants I raved about need to be soaked once a week or so. But with water terrariums, all you have to do is top off the water as it evaporates. If you have algae growing—and like your

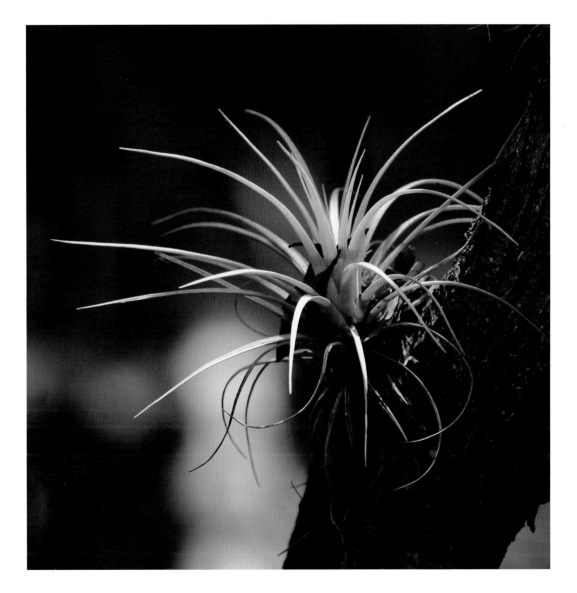

Glass Gardens

other terrariums, you can add charcoal pieces to counteract this—you can take about a quarter of the water out and replace that.

I've also seen some water terrariums that have betta fish swimming around, which is supposed to help control the algae, but I wasn't about to buy a fish just to take a picture for my book and then be stuck with him. So Google it if you haven't seen them; it's pretty cool. You could also use a snail. They love algae. So far, I haven't had a problem with algae in mine, so you may not see it either.

Another thing I don't have a problem with when I use water plants? Cats. I have a cat who *loves* nibbling on my plants. Shadow has managed to eat his way through so many of my plants that a bunch of my terrariums have been left with stumpy, leafless stems sticking out of the glassware. So far, he hasn't touched the water plants.

I had always thought that there was really only one kind of water plant—the kind you put in aquariums. But it turns out there are actually three types:

1. **Aquatic plants.** These are plants that you fully submerge in the water. You find them at pet stores with aquarium sections. I used an anubias plant, which is almost impossible to kill.

2. **Semi-aquatic plants.** You can use these plants partially submerged, with their roots under water.

3. **Floating plants.** Pretty self-explanatory. Some plants can live floating at the top of your container with the roots trailing in the water. Marimo Moss Balls are also floating plants.

So now that you've got an idea of how to get started with building your first water terrarium, head to your local pet or aquarium store and get your supplies! I'll have a couple of ideas for you, but as always, feel free to play with different plants and decorations.

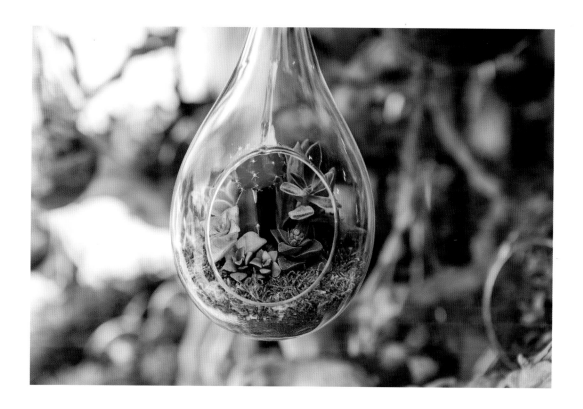

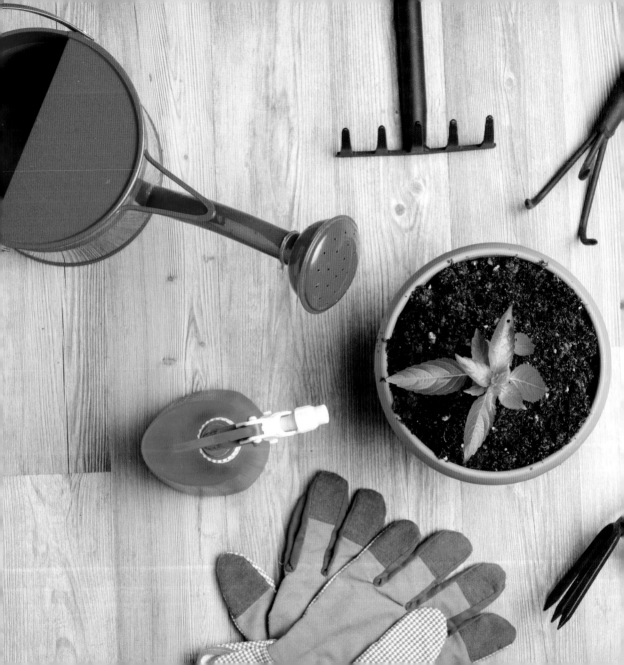

Getting Started

SUPPLIES

What you'll need to make all of your glass gardens:

Containers

When I started making terrariums, I was under the impression that all containers *had* to be glass. But really, who made that rule? While traditional terrariums are indeed created inside glass containers, you can plant your "glass" garden in virtually anything. From glass containers to old serving bowls, tea cups to wooden frames, your garden should be an expression of you. So make it quirky if that's who you are, or keep it traditional if you lean more that way. There's no wrong way to contain your garden.

Large retailers like Michael's Craft Stores and AC Moore, as well as plant nurseries, have some great containers; you'd come up with a ton of options if you went on a quick trip. If you can't find what you're looking for, though, raid your house. Or your mother's house. Or your friends' houses. There's bound to be something you can use—I guarantee it. A vase that's collecting dust on a shelf or a chipped serving dish you can't seem to throw away. Maybe a wooden salad bowl or a tea pot? Trust me. There's something.

You may also find your containers at charity shops and garage sales. Charity shops are *amazing* for this purpose. They have things you won't be able to get anywhere else for just a dollar or two. Two of my favorite charity-shop finds were a china dove with a hole in the top where I put an air plant and a sparkly purple rabbit with a hole in the side that I haven't quite figured out what to do with yet. Browse the shelves and keep an open mind. If you see something you like, grab it and get started!

Plants. Obviously.

Succulents and cacti are great choices because they're pretty easy to work with and keep healthy. Tropical plants are also good, and the ones I've used have been easy to bring back to life when you neglect to water them. Just make sure the plants you use together require the same amount of light and water. You can also use air plants and water plants, which come in a variety of shapes and sizes.

Soil, Stones, and Charcoal

Every terrarium you plant (except for air plants or water plants) will start with what I like to call the big three—stones, charcoal, and soil. You'll place a lining of stone on the bottom of your planter to help your plant drain and add some activated charcoal to keep your plants from rotting. You can find activated charcoal in pet stores in the fish section. I've used potting soil in a pinch, but there are also soils specific to the type of plants you're using. Cacti and succulent soil as well as tropical plant soil is readily available.

Watering Can

You'll need a watering can with a small spout to reach the base of the plants easily so you're not pouring water all over the place and can direct it right where you need it. Since there's a very fine line between just right and overwatering, this can be extremely helpful. A mister is also a great investment, especially for your air plants.

Terrarium Tools

I don't use specialized terrarium tools (though you could invest in them if you'd like), but I do use a really long pair of **tweezers** that I got at a craft store in the jewelry-making section. They help me reach into small planters to place plants or remove air plants to water. Sometimes it works and sometimes it doesn't. If you're less of a klutz than I am, you might have better luck.

I use a variety of regular **spoons** from my kitchen to add soil and dig.

Chopsticks are also a good tool, both to clear holes and help place your plants. If you're like me and you constantly stab yourself with cacti, you can use chopsticks to plant them.

I also recommend a **paintbrush**—the kind you buy in a package for your kids to paint with. Planting can be messy, particularly when you're trying to add soil around your plants in a small container. You can use your paintbrush to clean up the leaves and glass once you've allowed everything to dry a bit.

Decorative Items

I love using fun little decorations in my terrariums! I've spent far too much money on little fairies and goblins, dragons and stones with sayings on them, just to add some pizazz to my glass gardens. Keep in mind that some of the decorations you may want to include in your terrariums might not react well to the water or soil. Do your research. Ask questions. Find out as much as you can about your decorative pieces because like the agate I used below, some stone pieces may have minerals in them that will break down and go into your soil and could affect your plants.

There is an endless supply of decorative items available at gardening centers, craft stores, thrift shops, and yard sales. If you're a crafter like me, check your stockpile of craft supplies. Better yet, if you're a parent, go through your kids' stuff. My daughter hoards pretty things and I have found some pretty amazing decorations to use just by going through her room.

The only thing I wish I hadn't used as a decoration was a piece of agate that I borrowed from my daughter. I can't explain it, but I left it stuck in the soil for a few weeks before I pulled it out to use it in another terrarium and the stone had eroded. I had two in the same soil and it only happened to one for some reason. So just a note of caution: if you have something valuable you want to use in a terrarium, do some research to make sure it won't be destroyed by the soil. It's really the only time that I've encountered an issue like that, so I think I can confidently say that almost anything you can find can be used.

- Miniatures
- Stones
- Figurines
- Twigs and branches
- Sea shells
- Anemone shells
- Agate
- Beads
- Synthetic flowers
- Crystals
- Corks from wine bottles

And that's just a small list. Get creative. Find something that will make your terrarium *yours*. Put your stamp on it. Find something that means something to you or the person you're making your glass garden for.

Remember, anything goes—I almost used a live betta fish as a decorative item. And I have no idea what this rabbit was for in its previous life, but I see an air plant in its future.

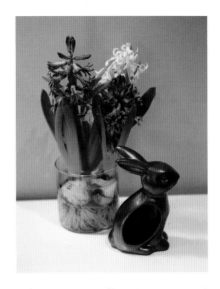

FIRST STEPS

So where do you begin? First, you'll need to go shopping for your supplies. Get your containers and plants and decorative items all lined up. Once you have those, you're ready to go.

Always, always, always clean your containers. Wash them inside and out and either dry them with a clean cloth or let them air-dry. Once the containers dry, you're ready to move on to the big three: stones, charcoal, and soil.

You need about an inch of stones on the bottom of your container so water has somewhere to drain. You can use aquarium stones or small decorative stones. Unlike many planters, there are no holes in the bottom of a glass container, so any water you put in is essentially trapped. If you have stones in the bottom, the water will drain into the stones instead of sitting in the soil forever. I haven't had to pour out any

excess water, so the charcoal is doing its job and absorbing it for me. But if you *really* overwater and you see the water just sitting in the bottom, you may need to carefully pour it out. Now you know not to add that much water.

Charcoal is an important part of your drainage layer, which keeps water from sitting in the soil and rotting the roots of your plants. Activated charcoal will absorb any toxins in the water and soil and help to keep your terrarium healthy.

Finally, the soil. I've tried a few types. You can use tropical plant soil, but I like the consistency of succulent and cactus soil. It's rich and easy to work with, and I find that my plants are healthier with it than when I tried to plant them using regular potting soil.

And before I stop talking about this—you really do need charcoal. I know you're questioning that one. Go to a pet store and go to the fish section. You'll find packages of charcoal where the filters are kept. Buy it. You'll thank me later.

Once you have your big three finished, you're ready to start planting!

But first—some notes on watering.

WATERING

I think the best person who could possibly give advice about how to take care of your plants is someone who has killed her fair share of them. I love plants, but I don't have the natural ability with them that my mother does. My green thumb is decidedly wilted.

So here are a few of the lessons I learned the hard way that will hopefully save you some money on plants you have to replace.

1. Watering is trickier than you might think. Glass containers don't have a way for the water to drain, so you need to be really careful not to overwater or the water will just sit in the bottom of the glass. Too much water and your plants will rot. Literally, rot. I've had a few cacti and succulents that looked fine, but upon closer inspection, had rotted at root level. So my succulent came off in my hand, and my cactus had rotted from the inside out and was hollow. I'm now much more careful about only watering them very occasionally.

2. Check the soil. If it's completely dry, water lightly and focus on the root area. Don't overwater! The best thing you can invest in is a watering can with a small spout. Failing that, use a turkey baster.

3. If the leaves of your plant are brown and it's spending a lot of time in direct sunlight, chances are it's burning. Not all plants like direct sunlight, especially for prolonged periods.

4. Some plants are more tolerant than others. I've used quite a few polka dot plants that are currently sitting on my back deck. Those terrariums are thriving because the polka dot starts to wilt when it needs water, letting you know exactly what it needs. As soon as I water it, the polka dot perks back up. I now use it as my water gauge. When the polka dot starts to sag, water the entire plant!

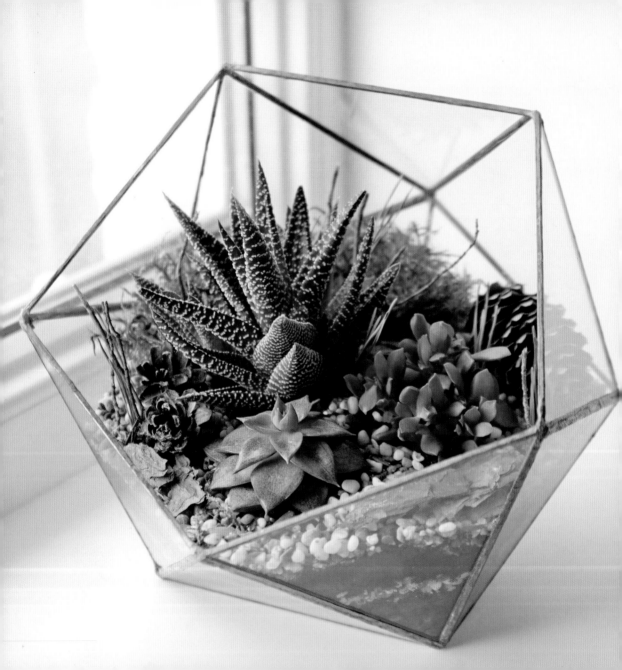

GARDENS

For every project listed here, you will need a container, the big three (soil, charcoal, stones), your chosen plants, and terrarium tools like those listed in the previous chapter. Additional supplies will be suggested, but feel free to get creative at any point!

A Little Bit of Color 23
A Rose By Any Other Name 25
Around the Globe 27
Buddha 31
Down the Shore 33
Elegant Dove 36
Fishbowl . . . Minus the Fish 39
Framed 41
Gnome Sweet Gnome 45
Grasshoppers 47
Hanging By a Thread 51
Ice Cream Sundae 53
In the Jungle 57
It's Starting to Look Like Spring! 59
Life's a Bowl of Cherries 63
Lights Up 65
Locket Up 67

Long Tall Sally 71
Love Always 73
Lucky Valentine 77
Moon Over Miami 79
Out of Control 81
Pretty in Pink . . . and Yellow! 85
Purple Reign 87
River Moss (Ball) 91
Ruby Red 93
Sticks and Stones 95
Tea for Two 97
Terraria 101
Texture, Texture, Texture 103
Under Glass 108
Urchin Glad You Thought of This? 111
Vials 113
Wired 115

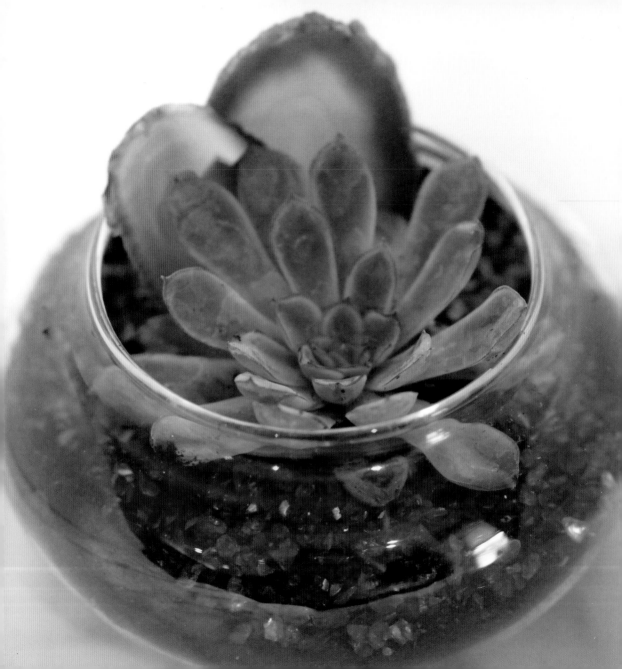

A Little Bit of Color

An easy terrarium to make with just a tiny splash of color. I took the name for this from the pink-lined leaves of this echeveria succulent!

WHAT YOU'LL NEED:

Glass bowl or vase | Soil | Charcoal | Stones | Terrarium tools | Succulent (perhaps echeveria!) | Black crystals, glass, or stones | Slices of agate

PUTTING IT ALL TOGETHER:

Super simple, with bits of color from the echeveria leaves and the slices of agate stones, this glass garden is a real eye-catcher.

Prepare your container with your big three—spread an inch or so of stones and sprinkle a layer of charcoal over that. Add a couple inches of soil or more, depending on where you want your plant to sit and how long the roots are. Now you're ready to plant your succulent in the center of the vase or container. Cover the soil with the crystals and place the agate together at the back, pressing the ends into the soil so they stand up lengthwise.

TIP! Sometimes less is more. Simplicity can be elegant, and you don't always have to crowd your container with a bunch of different plants. If you want to focus on just one, then do it.

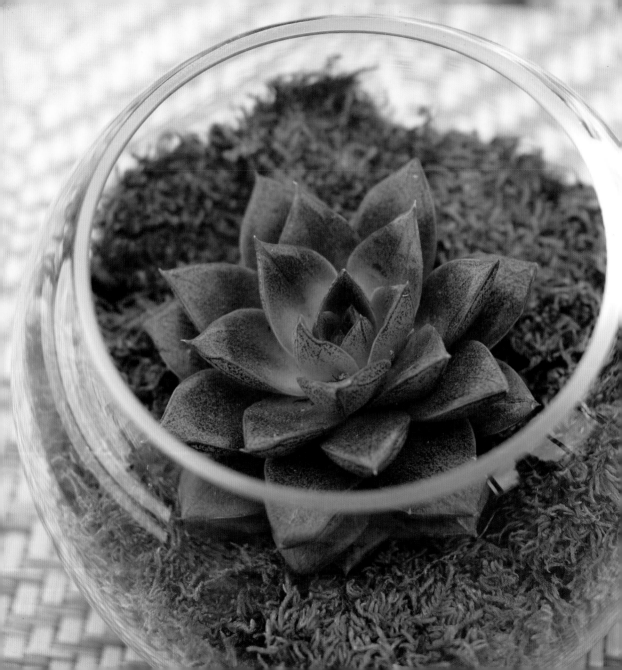

A Rose By Any Other Name

Simple and elegant—another way to use an echeveria succulent.

WHAT YOU'LL NEED:

Glass bowl or vase | Soil | Charcoal | Stones | Terrarium tools | Echeveria succulent | Preserved moss

PUTTING IT ALL TOGETHER:

I absolutely love this one! Well, I did until I knocked it off the counter and shattered it into a million pieces. Clearly, I'm quite graceful.

I found an absolutely gorgeous echeveria succulent while browsing around my local nursery and I knew instantly it needed to stand on its own. It was flawless. (At least until I dropped it.)

This glass garden is very similar to another project we've done called A Little Bit of Color (page 23). We use the same type of plant and a very similar container. You'll prepare your glass by washing it and filling it with stones, charcoal, and soil. Using a stunning echeveria (this one is fuller than the one I used in our other project) as

Continued on page 26

the centerpiece of the project, plant it in the center of your container. Instead of the crystals we used before, you'll surround the base of the echeveria with preserved moss.

I had just discovered the joys of preserved moss—specifically reindeer moss—and this was my first attempt at incorporating it into a terrarium. The cool thing about this moss is that, unlike a plant, you can tear or cut it into manageable pieces and place it exactly where you want it. The moss made the succulent look like it was nestled snugly in a forest somewhere. Like something out of a fairytale. (Again, until I dropped it.)

It's a much softer look than the Little Bit of Color project. There's something incredibly elegant about the combination of the pink-tipped echeveria and the moss. I see this piece used at a dinner party or setting off a formal room perfectly, but really, it would work anywhere.

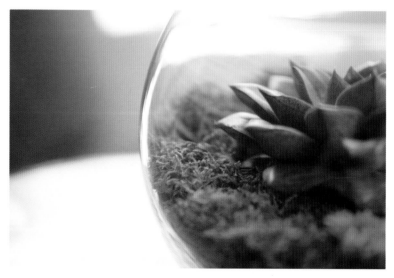

Around the Globe

This is a prime example of what, historically, would have been called a terrarium: beautiful tropical plants in a huge, round, closed glass container.

WHAT YOU'LL NEED:

Classic glass terrarium | Soil | Charcoal | Stones | Terrarium tools | Assortment of tropical plants

PUTTING IT ALL TOGETHER:

Oddly enough, one of the only things I hadn't tried by the time I finished my project list for this book was a classic terrarium in a big globe of a container. I happened to be doing some back-to-school shopping and came across a couple of amazing glass containers at a department store. Normally I wouldn't think to look there, but they were well-priced, so I picked them up.

I took this one home and cleaned it, then realized it was going to be tricky to even do something as simple as preparing it with stones, charcoal, and soil. The stones were simple enough; I tipped over the bag and poured them in. The charcoal was fairly easy, but then the soil went *everywhere*! I ended up having to clean the inside of the

Continued on page 29

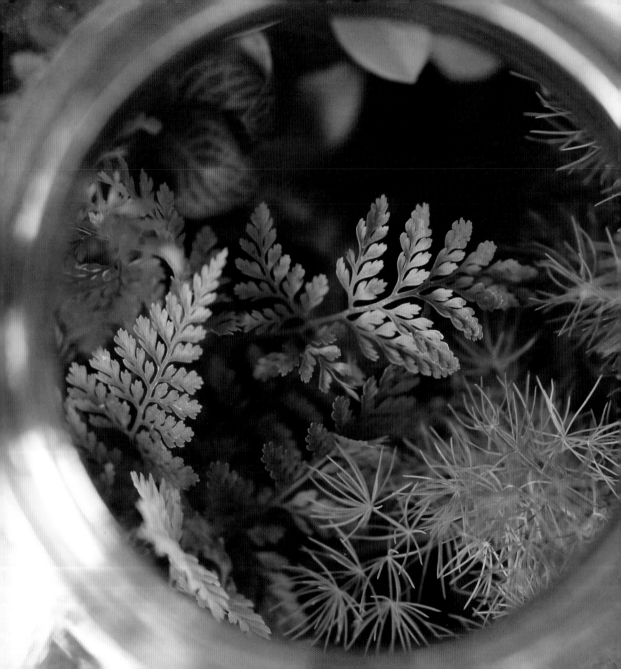

container with a paintbrush, holding my wrist at a very odd and uncomfortable angle.

Once that was done, I chose some plants and got to work. I reached in with a spoon and dug a hole for my polka dot plant. Luckily, I have small hands so I could reach in and carefully plant it without making too much of a mess, but I wasn't so lucky with the ferns. Soil got all over the other plants and the inside of the container. Again. I tried to brush it off with the paint brush, but it just made more of a mess. I decided I may as well finish planting and let everything dry enough to make cleaning easier later.

I had one more plant—unlabeled, as usual—to place in the terrarium. I loved the soft green color the first time I saw it, and I knew it would look perfect. And it did. But it made even more of a mess. I had switched to using long tweezers to try to place the plants, but as I've said before, I'm a bit of a klutz. I dropped the plant and had to reach in to rescue it anyway.

I was thrilled with this finished terrarium. Once the soil dried a bit, I was able to clean it with the brush easily.

TIP! Closed terrariums act as their own little ecosystem. You can keep them closed most of the time and let the humidity build so they basically water themselves. You'll need lots of light, but not direct sunlight. Watch your terrarium to make sure it doesn't have too much humidity. If there are large drops of water on the glass, open it for a while.

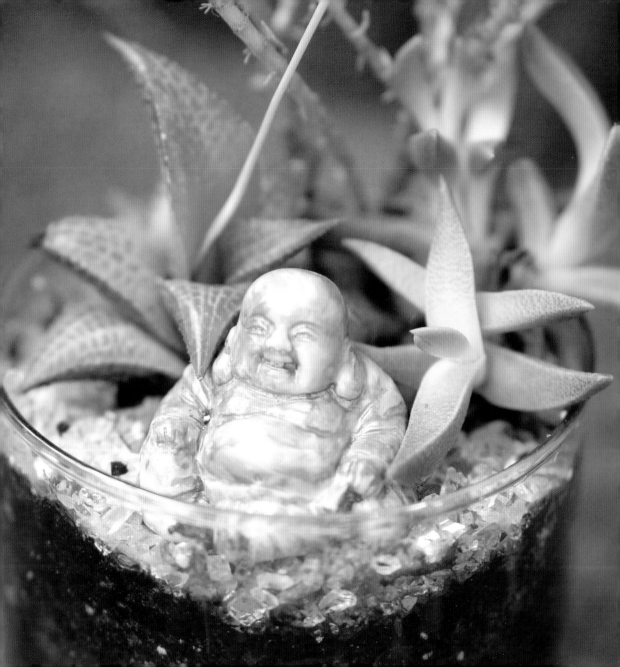

Buddha

This glass garden features a jade Buddha. What more could you possibly want?

WHAT YOU'LL NEED:

Glass bowl or vase | Soil | Charcoal | Stones | Terrarium tools | Succulents | Glass pieces | Buddha figurine

PUTTING IT ALL TOGETHER:

Like a lot of my ideas, this one came together because I picked up a decorative piece at a craft store that I thought was really cool. I'd guess that people with more gardening talent than I have plan their designs around specific plants or even the planters. But I have a weird habit of finding quirky little decorations and fitting the plants in around them as opposed to fitting the decoration into an existing arrangement.

I chose a deep cylindrical vase, thinking I'd plant everything below the rim. But as sometimes happens, I had to switch gears when it just didn't work that way. I ended up pulling it all apart and adding more soil so I could keep the container and raise the plants up higher. It might not be a traditional terrarium if it's raised up like this, but I have

Continued on page 32

quickly learned that your glass garden can be anything you want it to be. If you want it to spill out over the top of your container, then that's exactly how you should design it!

As always, clean your container and prep it with the big three—stones, charcoal, and soil. Place your plants around the outside to get an idea of what will look good where. I chose a howarthia, which is also called a "Star Window Plant" or a "Zebra Cactus." It's a really pretty star-shaped succulent with beautiful white markings. I also used a trailing santolina plant and some type of succulent that wasn't identified on the container but I think is a type of aloe. All the plants are beautiful, but I really wanted the eye to go right to the Buddha. So rather than placing it subtly under a plant, I placed it front and center and planted the succulents around it.

Once you have everything where you want it, sprinkle the glass bits on top of the exposed soil to add sparkle.

TIP! It's hard to move things once you've spread the glass pieces around. (I know, I tried.) They get mixed into the soil very easily. I ended up having to dump everything out and start over, so try to finalize your placement before you add glass or other small stones to your container.

Down the Shore

A stunningly bright air plant terrarium—or aerium—that will remind you of a day down at the shore. Sand. Grass waving in the breeze. Sun glinting off colorful pieces of sea glass.

WHAT YOU'LL NEED:

Clear glass container | Sand | Terrarium tools | Air plant | Plant-safe glue (such as G-1000) | Sea glass | Piece of driftwood

PUTTING IT ALL TOGETHER:

When choosing an air plant for this project, make sure it'll be the right size and shape to rest on the driftwood. It should look like sea glass, ideally. You may find your other supplies—driftwood and sea glass—on the beach itself, or purchase them from craft stores.

The first thing you need to do is figure out how you're going to place the air plant on the driftwood. I hate to admit it, but I spent an embarrassing amount of time moving my air plant around and trying it out in slightly different angles.

When I finally found the perfect position, I put a dab of glue on the wood and one on the plant and pressed them together. I watched about fifteen minutes of *Gilmore Girls*

Continued on page 35

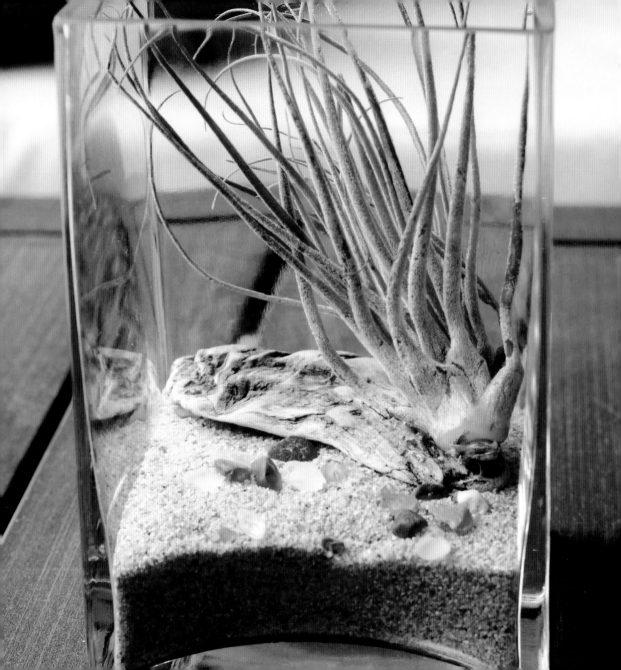

while I held the plant in place and waited for the glue to dry. (Thank you, Netflix!) But then I had to run an errand, so I set my plant down on the counter carefully, expecting to pick up where I left off as soon as I got home. What I wasn't expecting was to find my air plant lying on the counter beside the driftwood. Lesson of the day: even if you think the glue is dry, it's not! Hold it longer! I cleaned my air plant and driftwood and started over, making sure to hold it twice as long this time (about half an hour).

With the air plant finally attached to the driftwood, the rest was a snap. This terrarium literally couldn't be easier.

First, clean the glass inside and out and dry it well. Fill it with an inch or two of sand. I used a darker, slightly grainy craft sand that reminded me of the beach on the east coast. If you want your terrarium to look a little more Caribbean, you can use a finer, lighter sand.

Carefully place the driftwood on top of the sand. If you've actually let the glue dry, you can move it until you've got it positioned just right.

Sprinkle sea glass around the air plant, and you're done!

Put your terrarium in a window or sunny spot so the sea glass catches the light.

TIP! I realize in other projects, I tell you not to glue your plants to things (see the Elegant Dove project) but in this case, I got away with it. I was still able to soak my air plant by filling a glass of water to the top, flipping the piece of driftwood upside down, and balancing it across the top of the glass, leaving the air plant in the water.

Elegant Dove

A perfectly peaceful decoration that would make an excellent
Easter or Christmas ornament.

WHAT YOU'LL NEED:

Ceramic container | Soil | Charcoal | Stones | Terrarium tools | Air plant | Preserved
moss | Glue

PUTTING IT ALL TOGETHER:

Another super easy home decoration made with a thrift-shop find. This dove is actually
a candle holder with a perfect spot to put an air plant. All I had to do was glue some
preserved moss in the hole where a candle would sit and set the air plant on top. Simple.

Truthfully, I didn't really think my project through on the first go 'round and glued the
air plant in place—which meant I'd never be able to soak it in water. Luckily, the glue I
used didn't stick well, and I removed it without damaging the air plant.

TIP! Don't be afraid to use odd-looking containers. Visit your local charity shop and
walk around the glassware section. You'll be amazed at the things you'll find.

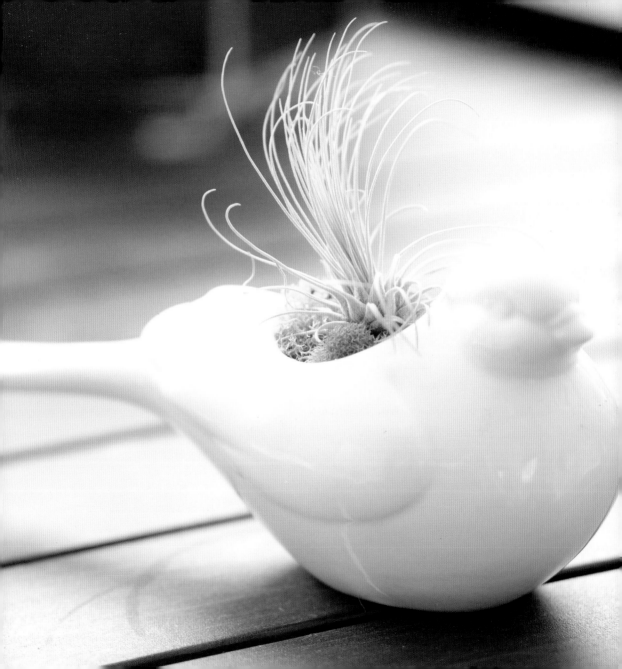

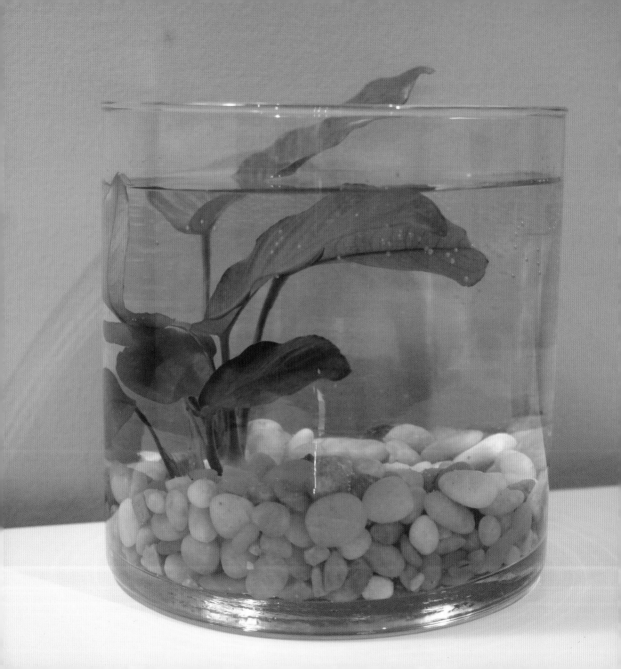

Fishbowl . . . Minus the Fish

What can I say? I think this would make an awesome betta bowl.

WHAT YOU'LL NEED:

Glass container | Water plant, such as an anubias | Aquarium stones | Water

PUTTING IT ALL TOGETHER:

I've got to be honest here: I was dying to put a betta fish into this terrarium, but then I'd be stuck with a betta fish. And I'm notorious for the fact that betta fish don't tend to survive long in our house. But if you're looking to add a betta to your family, this terrarium would look really cool with a fish swimming around in it. Just saying.

In my case, I'm going to leave it simple, just in case I cave and get a fish. I may put a decoration in it. I may leave it alone. Either way, I love the simplicity of this water terrarium. It couldn't be simpler to make and, so far, I haven't really had to do anything to keep it healthy.

Using a clean glass container, fill it with a few inches of aquarium stones. I used a spoon to clear a space where I wanted to put the anubias and gently covered the roots

Continued on page 40

up with stones. I actually had to move mine because I decided after the fact that it would look better if it wasn't centered, but that was pretty simple, as well. Once I had it placed where I wanted it, I slowly poured water in until it was almost completely submerged. You can leave this type of plant partially or fully submerged, but I decided to leave the top leaf out of the water simply because I liked the way it looked. Anubias plants are pretty tolerant, so this is a great project for people who aren't quite sure if water terrariums are for them.

TIP! If your anubias is getting too big, you can trim some of the leaves off near the bottom. If you trim too much, you can make a tiny nick in the stem and it will start to grow a new shoot.

Framed

This is a frame you can display without the embarrassing family photo.
It's another super-easy, lightning-fast decorative piece of art
that you can display on a table or hang on your wall.

WHAT YOU'LL NEED:

Air plant | Frame

PUTTING IT ALL TOGETHER:

Once you've selected your air plant (you'll need one that will rest in your chosen frame), this is the easiest possible aerium ever. Seriously.

You'll need a frame with some depth for this, so a craft frame works well, not necessarily a standard picture frame. I found an unfinished wooden frame at Michael's Craft Stores and removed the back. I decided to leave it unfinished because I liked the way it looked, but you could paint or stain it if you prefer.

There are really only two steps to this project. First, place your air plant onto your frame. I found a great plant that rests on the frame and fans out around it. Then, find a

Continued on page 42

place to display your frame. This frame could hang on the wall or sit on a table. I have mine on my kitchen table. You could add moss around it if you want to fill it out a bit. You can glue that in place, but don't glue the air plant in this project. You'll have to leave this one loose so you can water it.

It's really that simple.

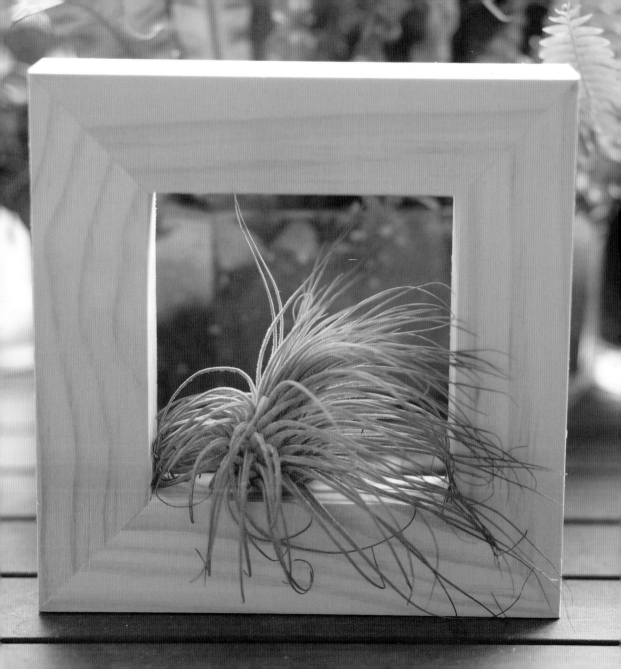

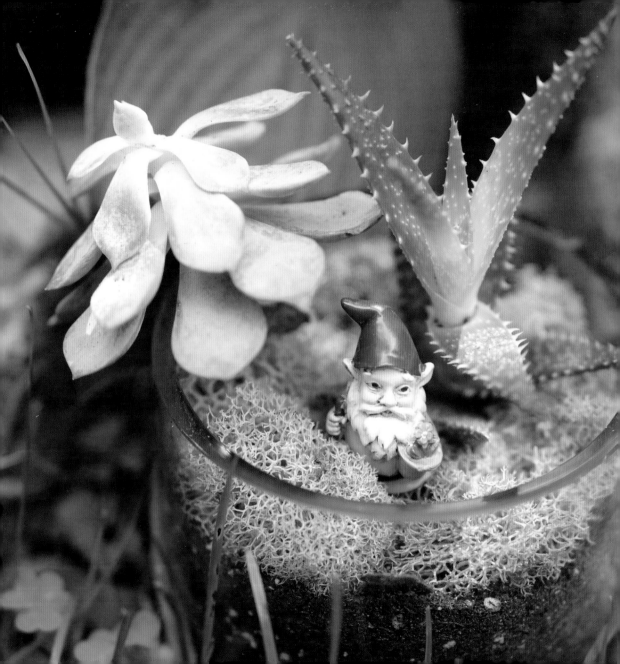

Gnome Sweet Gnome

A magical glass garden that reminds me of *Alice in Wonderland*.
Succulents, moss, and a little guy hiding under the leaves.

WHAT YOU'LL NEED:

Glass container | Soil | Charcoal | Stones | Terrarium tools | Succulents (aloe vera, echeveria) | Preserved moss | Gnome or figurine of your choice

PUTTING IT ALL TOGETHER:

I can't tell you how happy I was to be using this little guy in a terrarium. Initially, the entire garden was a couple inches lower in the container, but I couldn't see the gnome, which I found at the local nursery, so I took it apart and replanted it. While traditional terrariums would have been planted inside a globular glass container, they've now evolved, and there's no reason you can't, too. Don't worry about the rules (with the exception of always using the big three). Make it look any way you want it to.

Clean your container and prepare it with the big three—stones, charcoal, and soil. Place your succulents and make sure you're happy with them. Now is the time to move

Continued on page 46

them around if you're not satisfied. I used succulents that have some height, and I wanted them to stand up above the container so I could "hide" my gnome under them. I thought it would look like he was wandering around the forest—if the forest had aloe trees. Besides the aloe, I used a tall echeveria with a color that reminded me of a spruce tree.

Arrange preserved moss around your plants and set your figurine underneath the succulents.

Grasshoppers

A piece of art that will almost jump off the wall. (Get it? Grasshoppers? Jump?) A framed piece that would work anywhere and with any kind of pottery or vase.

WHAT YOU'LL NEED:

Ceramic container | Picture frame | Strong glue | Paper, your choice of color | Soil | Charcoal | Stones | Terrarium tools | Small plants (such as spider plant or cacti)

PUTTING IT ALL TOGETHER:

I was trolling around the local Goodwill, looking for interesting things to plant in and came across two matching pieces of handmade pottery with grasshoppers on them. I wasn't sure how I was going to use them, but I knew I had to buy them and figure something out later. Once I found the frame at the same store, I started to form the design in my mind.

As always, clean your containers well. In this case, clean your frame, too. The cleaner both pieces are, the better they'll stick when you glue them. Just this once, we're going to leave the big three until later in the process.

Continued on page 48

First, cut your paper and put it in the frame. The cool thing about this project is that you can change the paper. You can coordinate with whatever room you're placing it in, or if you're giving it as a gift, you can just coordinate with the pottery. So if your containers are neutral, you can add anything you want to the background. Mine aren't neutral at all, obviously, so I used gold paper.

I tried a couple different things to attach my pottery pieces to the frame. They're going directly onto the glass, so they have to hold. A glue gun didn't work, and extra-strength glue dots didn't work, but my trusty tube of E-6000 did the trick. You'll want to put a couple dabs of glue on your container and on the glass of your frame. Place it carefully! If you make a mistake, you can move it if you act fast, but once it dries, you're probably out of luck. Hold your container tightly onto the frame for a minute. After that, you can lay it down and let it dry according to the directions on the adhesive. I put heavy cups against the container so it wouldn't shift. I learned that trick the hard way after I walked out of the room on one of my test drives of this project and came back to see the container lying on the counter and not on the frame.

Once the glue has dried—and you'll want to err on the side of caution and let it cure for a while—you can start with your big three: stones, charcoal, and soil. You can prop your frame upright now. Then place your plants in the containers. Now you've got a really original and unique piece that can be hung on the wall or displayed among your family photos.

TIP! Don't be afraid to use things that wouldn't normally be considered terrariums. It's okay to branch out and create something completely unique. Use your imagination and experiment!

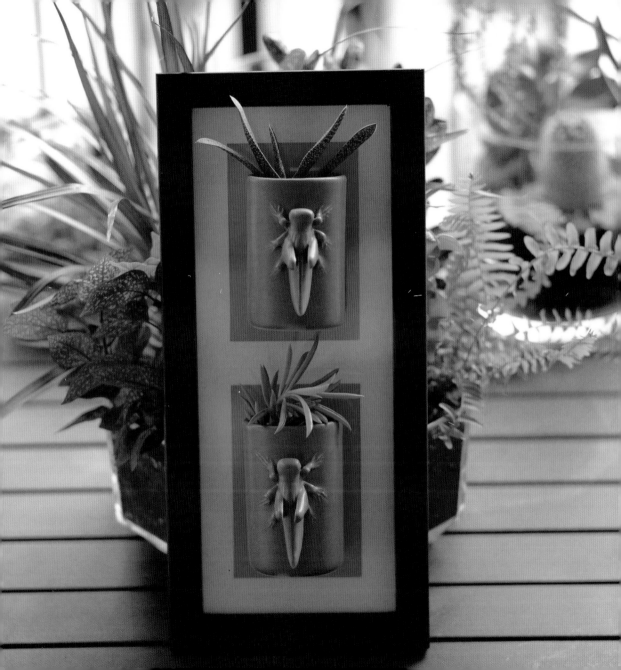

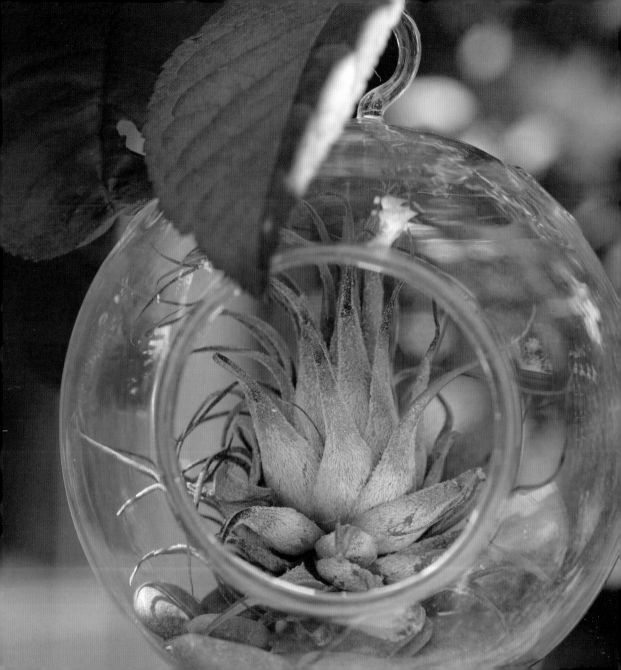

Hanging By a Thread

A gorgeous aerium to hang inside or out.

WHAT YOU'LL NEED:

A hanging terrarium (usually a glass globe or teardrop-shaped container) | Air plant | Stones | Twine

PUTTING IT ALL TOGETHER:

I LOVE THIS TERRARIUM SO MUCH!

Ahem.

I saw this container—I'm sure it has a name but I don't know it—at the nursery and although I wasn't sure what I was going to do with it, I knew I needed to buy it. I didn't want to plant anything in it because I really wasn't confident enough to try it, so I decided to put an air plant in it instead.

I cleaned and dried the container carefully and chose an air plant that would sit in the center but reach toward the top and sides. It was perfect. Before placing it, I

Continued on page 52

put a layer of stones I had found at the beach that had been worn down to a perfect smoothness.

Now I was ready for my air plant. I had to be careful putting it in so I wouldn't break off any of the leaves, but once it was in there, it fit beautifully. I finished by tying a piece of twine to the top and then I hung it outside.

Ice Cream Sundae

A super bright glass garden planted inside an ice cream dish.

WHAT YOU'LL NEED:

Ice cream cup or margarita glass | Soil | Charcoal | Stones | Terrarium tools | Plants of your choice | Agate

PUTTING IT ALL TOGETHER:

Another awesome glassware find from a charity shop. I loved how whimsical it was and instantly started trying to brainstorm something cool for it. For yours, be sure to select something colorful and quirky!

I prepared my container (cleaned it inside and out and then inserted the big three—stones, charcoal, soil) and then I played around with the placement of my plants. I had chosen the spreading club moss (a spiky succulent that is some kind of sansevieria) because I loved the way it spread out. Hence the name, I suppose. With the spiky succulent I was using, I knew I needed to add some softness to the glass garden and moss seemed like the perfect fit. Imagine my surprise when, despite its mystical sounding name, I discovered that *Sedum morganianum* is not an ingredient from

Continued on page 54

Potions class. I had some burro's tail (a trailing succulent, also known as *Sedum morganiamum*) and decided to use some shorter pieces of that to finish the design. I let it fall over the side a bit and had my glass garden!

It took some rearranging, but I finally got the plants where I wanted them and put the agate in at the back. The stone pieces really played up the color of the container and added to the playfulness I was trying to create.

TIP! Embellishments (stones or other decorative items) are a great way to add character and whimsy to your design.

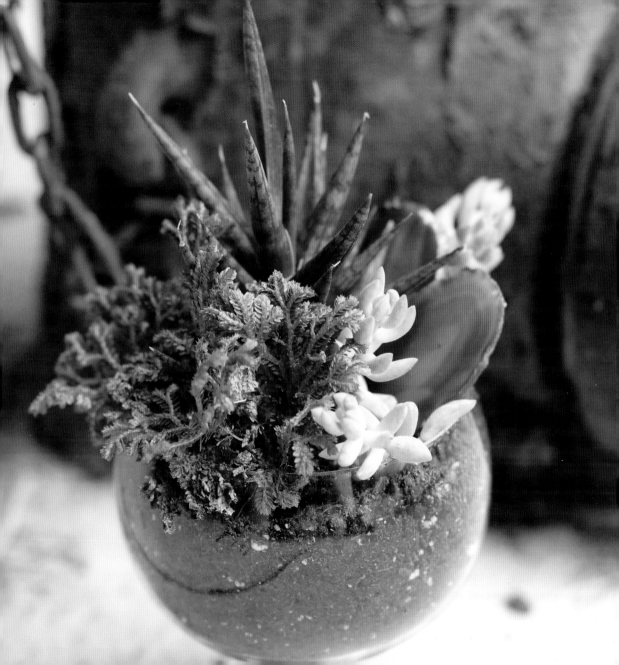

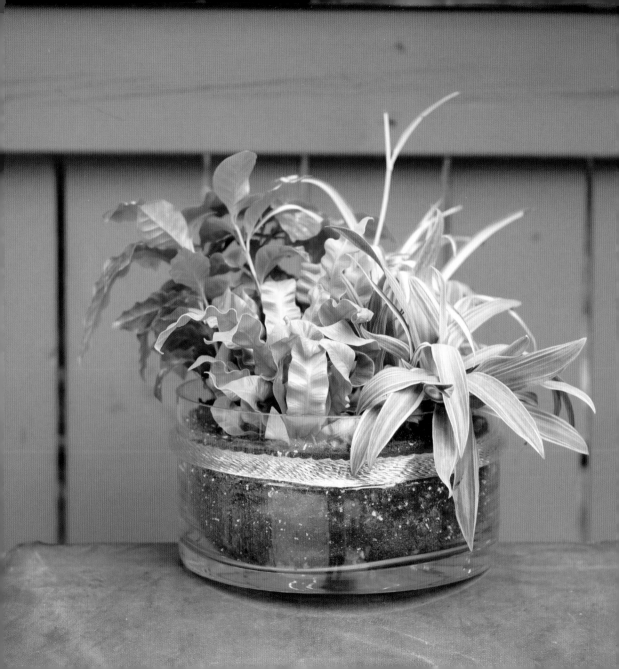

In the Jungle

A wild-looking collection of tropical plants for you to get lost in.

WHAT YOU'LL NEED:

Glass bowl or container | Soil | Charcoal | Stones | Terrarium tools | Tropical plants

PUTTING IT ALL TOGETHER:

Clean your glass container well and let it dry. For this design, I used a crystal serving dish with a broken handle, but as we've discussed, you can use whatever you'd like. Prepare it with the stones, charcoal, and soil.

The plants selected for this project should give your terrarium a wild look, so tropical plants fit the bill! I chose a Pothos plant, a spider plant, Moses in the cradle, and a bird's nest fern. I always set my plants gently on top of the soil so I can get an idea of where I'd like to plant them before I actually start digging. I can move them around as much as I want without making too big of a mess. Truthfully, I still sometimes have to dig them back up, but this is a good start.

Once you know where you want everything, start planting!

Continued on page 58

I planted the Moses in the cradle first. I knew that the pink-tinged leaves would be the most eye-catching part of the arrangement, so I put it right at the front. The bird's nest fern worked beautifully right beside it, and I finished with the spider plant and Pothos in the back because they had more height than the other two plants. Once they were planted, they spread out beautifully.

It's Starting to Look Like Spring!

It really doesn't get any more simple or chic than this one.

WHAT YOU'LL NEED:

Glass container | Hyacinths | Water

PUTTING IT ALL TOGETHER:

I'm writing this while a storm hurls giant snowflakes past my living room window, but there's something about the intoxicating scent and vibrant color of hyacinths that immediately makes me think of spring. If I'm being honest, I had no idea you could use them in water terrariums, but I saw a few people online using them and had to try it out myself. So far, they're thriving, and every time I see them on my counter, I'm reminded that (thankfully) spring is right around the corner.

The hardest part of this simple water terrarium is unplanting your hyacinths. You'll need to dig them up and clean the roots off well under running water to get all the dirt

Continued on page 61

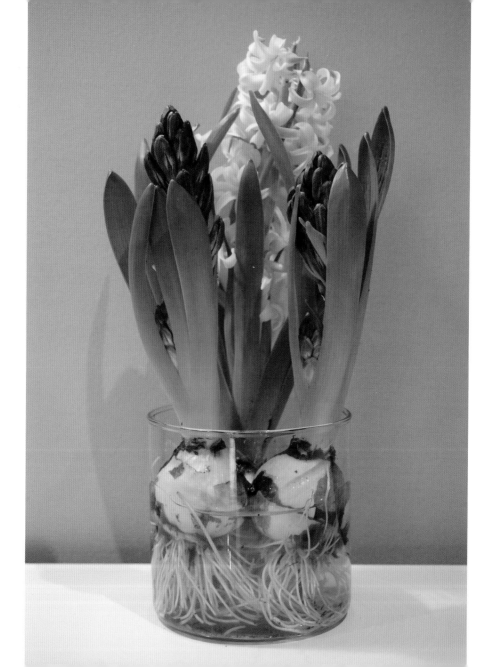

off. Once they're clean, place them in your container. It'll have to be small enough to hold your plants in place. I used three different hyacinths to fill my container. Once they're placed to your satisfaction, add water. And that's it! Sit back and enjoy your little bit of spring.

TIP! Make sure you clean the roots! If you don't get all the dirt off, you're going to have some pretty dirty-looking water. As the water in your terrarium evaporates, make sure you add some back in.

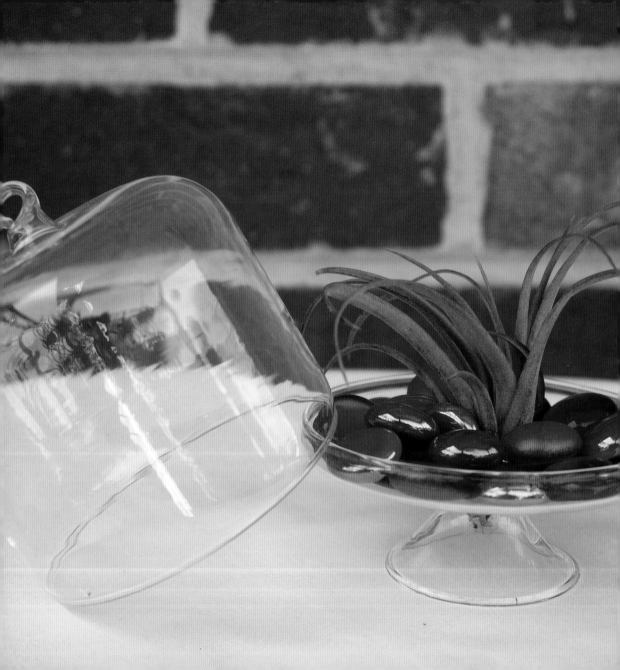

Life's a Bowl of Cherries

There's something about the brilliant red of this piece that makes me think of fresh cherries from my tree out back. A simple but beautiful centerpiece with lots of color.

WHAT YOU'LL NEED:

Glass container with a cloche (a dome to cover it) | Air plant | Red marbles or decorative stones

PUTTING IT ALL TOGETHER:

Clean the container and dry it well. The base of my container had a hole in it, which was a perfect place to hold the air plant. But if yours doesn't have that, don't worry. You can layer the stones and then form a hole in the middle for your plant.

You can put the roof, or cloche, on top and keep your plant covered, or you can keep it open. That's completely up to you!

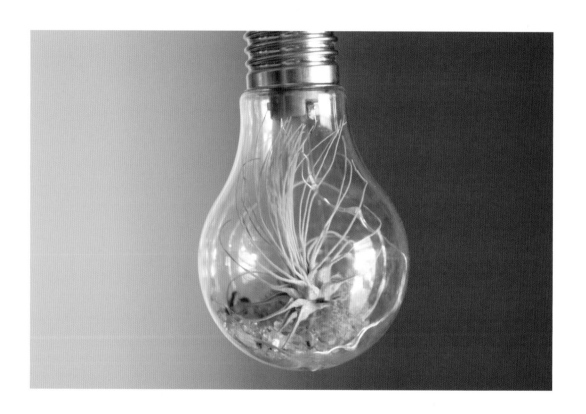

Lights Up

Light up your home with a unique piece of living art. This is an incredibly unique piece that could work as an ornament for your holiday tree, as a night-light, or hanging around a patio.

WHAT YOU'LL NEED:

Decorative lightbulb | Small air plant | Sand | Decorative stones or glass bits | Shells | Sea glass | Preserved moss (optional)

PUTTING IT ALL TOGETHER:

One of the coolest containers I came across was a refurbished lightbulb that had been gutted and had a string of tiny sparkle lights added to the interior. I hung onto that one for a while, trying to decide the perfect design for it, figuring it would make a good night-light or tree ornament. There were only so many things I could fit inside a lightbulb. I chose a tiny air plant that I could remove easily to water. That was the easy part.

If you're interested in replicating this project, you may need to do some searching for these lightbulbs. I stumbled across mine at a garden center where they had them in

Continued on page 66

clear, yellow, green, pink, and blue. (Thinking of those colors now, I bet this project would make great decorations for a baby shower!)

Using my trusty funnel, I put some little pieces of mirrored glass in the bottom. I thought they'd reflect the light nicely. I tried to add my air plant, but it was too empty. It didn't look right. A little tuft of preserved moss filled it out nicely. I hung it from my ceiling for a while and then decided I wanted to take another crack at it.

In the meantime, my air plant had dried out a bit. My fault—I forgotten to water it. But the dried up plant reminded me of sea grass, much like the Down the Shore (page 33) design I had already done.

I emptied out the bulb and started over with a little bit of sand, a couple shells, and some sea glass for color and sparkle. I added my air plant back in. There was something about this one that I loved. I could still use it for a nightlight or ornament, or I could display it in a bowl in the center of my table with shells and sea glass around it. Or put it on my back porch. Or even in the bathroom!

TIP! Trust your instincts and don't be afraid to start over if you're not happy with the results you get the first time. Your second or third try might be exactly what you were looking for.

Locket Up

A modern and eclectic take on an old classic. I have to admit that I'm not a big jewelry person; I tend to keep it pretty simple. But I do have a daughter who absolutely loves to accessorize. I gave her one of these lockets and she loves it!

WHAT YOU'LL NEED:

Locket with a glass or plastic front | Small air plant | Preserved moss (optional) | Handful of seeds (optional) | Glue (optional)

PUTTING IT ALL TOGETHER:

Once you have all the elements, this is one of the most foolproof projects in the book. Your locket can be glass or plastic, but I found glass worked better for me because it tends to be clearer so you can see your plant in greater detail. Craft stores like Michael's do carry these pieces of jewelry.

Once you choose a locket and a plant that work well together, the only trick to this project is placement (and getting things to stay where you put them once you close your locket). Open your locket and put something in it. It's as simple as that.

Continued on page 68

In one locket I created, I used a little clipping of preserved moss. Preserved moss comes in some pretty brilliant colors, so you can get creative with one or two pieces. Seeds from dandelions or milkweeds also look great in these lockets. I used the flower bud from an air plant in another. These smaller objects move around a lot, but you can fix that with a tiny drop of glue if you want.

If you choose to put an air plant in the locket and give it as a gift to a loved one, don't forget to remind the recipient to water it every so often to keep it bright and colorful!

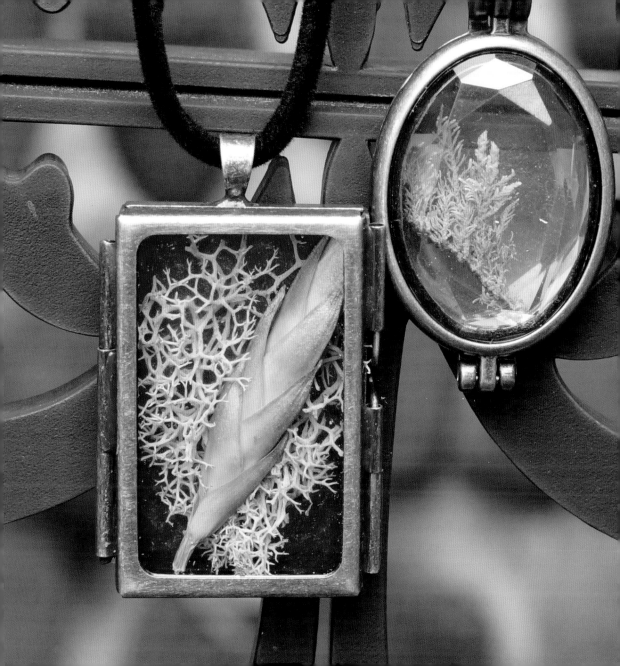

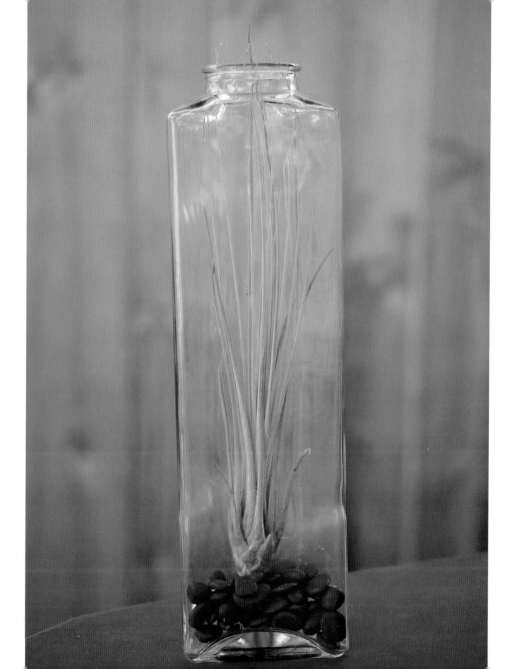

Long Tall Sally

Simple. Simple!

WHAT YOU'LL NEED:

A tall, thin container or vase | Super long air plant | Stones

PUTTING IT ALL TOGETHER:

Once I discovered how easy air plants were to take care of, I kind of went overboard and bought a bunch of different ones to play around with. I had one that I loved the look of, but it was six to eight inches long and wouldn't really work with any of the projects I had planned. I was in a thrift store one day, buying more glass than I could ever possibly use, and saw a cool, angular glass container that I thought would be interesting—and instantly thought of my super long air plant.

I dropped some stones into the bottom and carefully lowered the air plant in. It fit perfectly. It was really hard to take a picture of because of the thickness of the glass, but it made a really interesting and unique aerium.

Continued on page 72

TIP! I've stuffed air plants into some pretty weird containers and even made one project completely out of wire. Something I learned the hard way: *make sure you can get it back out!* Air plants need to be soaked every week or two so you must be able to remove your plant from its container.

Love Always

Succulents, cacti, and a cute little something extra hidden away.

WHAT YOU'LL NEED:

Glass container | Stones | Charcoal | Soil | Terrarium tools | Mixed plants | Decorative stone (optional) | Figurine of your choice (optional)

PUTTING IT ALL TOGETHER:

I once went shopping for a fish with my daughter, and we started picking out the little guys based on how they looked. We found a cool little sucker fish called a plecco who was a couple of inches long and sticking to the side of the glass. We figured he'd be perfect for our tank. Luckily, I asked the aquarium guy a few questions and was surprised to find out that he could grow to be twelve inches long. Way too big for our little tank.

I hate to admit it, but I tend to choose plants based on how they look together and how they fit into the container I'm planning. I don't always do much research on how they'll look a few months later. As a result, I planted this one without doing any research, and what started as a beautiful terrarium that fit perfectly in the container has morphed

Continued on page 75

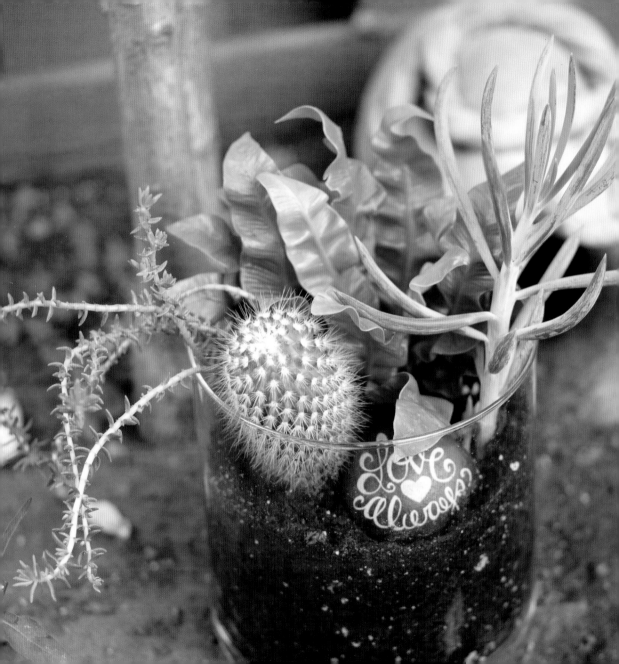

into one with a *huge* plant that has vastly outgrown the vase. When you go to pick plants at a garden center or nursery, *ask questions!* You should, at the very least, find out how big your plants are going to get.

Like many of the projects I've started, I planned this terrarium around the container and the stone I found and picked my plants, maybe not in the most intelligent way, but because I thought they'd look great together. I used a mix of cacti, succulents, and tropicals. I found the bird's nest fern in a section that carried air-purifying plants. I added a small, round cactus and then looked for trailing plants that would hang over the side of the container. I found this cool one that, as usual, wasn't identified on the pot. I did a little digging, and I think it's a variety of santolina, which is easy to grow and had the trailing effect I was looking for. All I needed to finish it was a plant with some height. I found one I loved, which I've since identified to be a blue chalk sticks succulent. It's got the height I was looking for, and I loved the shape of it. What I didn't realize was that in a couple of months, it would triple in size. Lesson learned.

Start with your big three—stones, charcoal, and soil. Add your plants, moving them around until you're satisfied with their placement. Leave a little space right up front for your stone or figurine. Simple as that! The one I chose says *Love Always*. You can buy one at a craft or garden store or you can make your own. All it takes is a smooth or polished stone and a paint pen. I'd also spray it with something to keep the paint intact.

TIP! When you locate plants you want to use, ask someone at the nursery what you can expect. If the worker is unsure, sometimes you'll get lucky and there will be some information on a tag in the planter, or they'll print the name of the plant on the pot. Look it up. Ask questions. Or you'll end up with a foot-long plant taking over your glass garden.

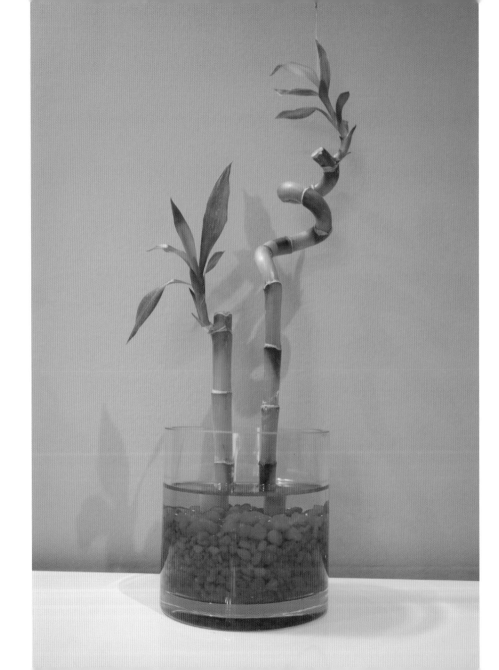

Lucky Valentine

A simple water terrarium to bring you luck.

WHAT YOU'LL NEED:

Glass container | Lucky bamboo | Red stones | Water

PUTTING IT ALL TOGETHER:

This is about as simple as it gets. Yes, I say that about all my water terrariums, but it really is true. Start with a clean glass, and place your bamboo in the middle. If you're using more than one, you can put them approximately where you want them to stay. I used two pieces—one short, straight piece and one long, curly piece. Holding them upright with one hand, pour in your pebbles or stones (I used aquarium stones) until you have enough to keep your bamboo secure. It'll take a few inches of stones to keep them in place.

Although we call this plant lucky bamboo, it's actually not really part of the bamboo family at all. It's a tropical water lily from Africa. And there's something so simple and chic about it that decorative elements were unnecessary.

TIP! You'll want to give your bamboo lots of bright light, but it should be indirect or the leaves could burn. Because bamboo is sensitive to chemicals, distilled water is the safest bet to keep your plant healthy. Lucky bamboo is said to give good fortune to anyone who lives in the space where it's grown.

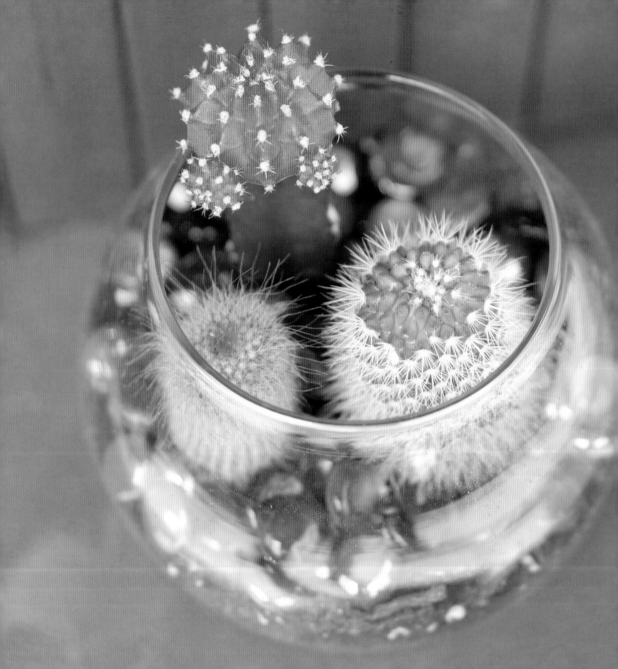

Moon Over Miami

Given its name by the stunning red moon cactus rising above the rim of the bowl.

WHAT YOU'LL NEED:

Glass bowl | Stones | Charcoal | Soil | Terrarium tools | Several cacti | Glass marbles or stones

PUTTING IT ALL TOGETHER:

Prepare your glass bowl by washing and drying it. Add an inch of stones, a layer of charcoal, and several inches of soil. I chose a red moon cactus for this project, but they come in a variety of colors—red, pink, yellow, and orange. All of them would work well in this glass garden.

Arrange your cacti around the outside of your container until you're satisfied with their placement. Once you have a plan, you're ready to get started with planting. Dig a hole in the soil with a spoon for your first cactus. I planted my moon cactus first and then had to place the others around it without impaling myself.

Be careful! If you can possibly avoid rearranging your cacti, do it. Chances are, you're going to stab yourself at some point. Try gardening gloves or chopsticks. You can also

Continued on page 80

use long tweezers. I've tried all of them and always somehow end up placing them by hand. And stabbing myself several times. Whatever works best for you. Sadly, what works best for me usually involves planting everything and then realizing I don't like the placement and then digging it all back up again. It's easier for me to just grab the cactus and hope for the best. Several rearrangements later, my hands are usually bleeding with spines stuck in them in various places, but at least I'm happy with the result!

Once you have your cacti planted, put a layer of stones or marbles on top of the soil that will highlight the color in your cacti.

Find a spot for your new glass garden and enjoy!

Out of Control

Sometimes you just want to take the plants you've been hoarding and go crazy!

WHAT YOU'LL NEED:

Shallow glass container | Stones | Charcoal | Soil | Terrarium tools | Assortment of tropical plants | Glass stones

PUTTING IT ALL TOGETHER:

Sometimes I head out to the garden center and fill my basket with plants that I don't really need or have room for. I grab them because they look cool but have no actual plans to use them. So I end up with a counter full of plants that I stare at for days but don't do anything with. Days turn into weeks, and I either end up killing them or sometimes getting inspired to create something new.

So with a pile of plants cluttering up my kitchen and guests coming for dinner, I decided to use as many as plants as I could and Out of Control was born.

I had as many glass containers as I did plants, so I randomly chose one I had really liked when I bought it but had not yet found use for. I had already cleaned it, so all I

Continued on page 82

had to do was put stones in the bottom, sprinkle it with charcoal, and add soil. Once I had that done, I was ready to create.

This was one of the few times I didn't have to rearrange things because it really came together pretty perfectly. I wanted it to look wild and out of control, and I think that's exactly the effect it has.

I used a polka dot plant for color and a red-edged dracaena behind it. I loved the colors together! I had another colorful plant that I wanted to use, so I planted a croton in shades of red, yellow, and green. I had one spot left and filled it with a bird's nest fern. I thought I was finished, but there was still a bit of an empty space, so I used a fern I had sitting around. I couldn't have planned it better if I had sat down and actually *made* a plan. (Which, if you haven't figured it out by now, I never really do.)

I finished off this glass garden with frosted glass stones.

TIP! When you have leftover plants, just put them together and see what you come up with. Sometimes plants you bought with no actual idea in mind can come together to make something incredibly beautiful. If you're not the spontaneous type, you may find yourself doing a little research first to make sure the plants can inhabit the same container without issue.

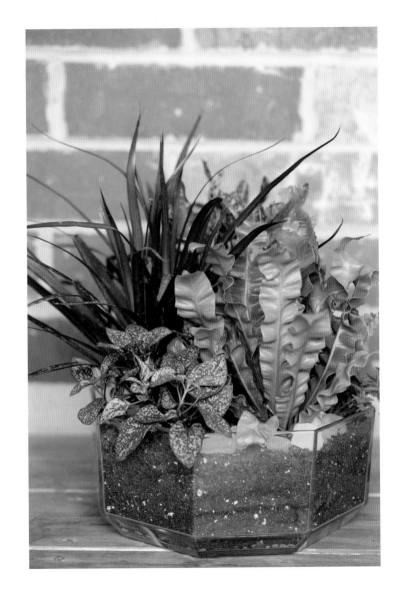

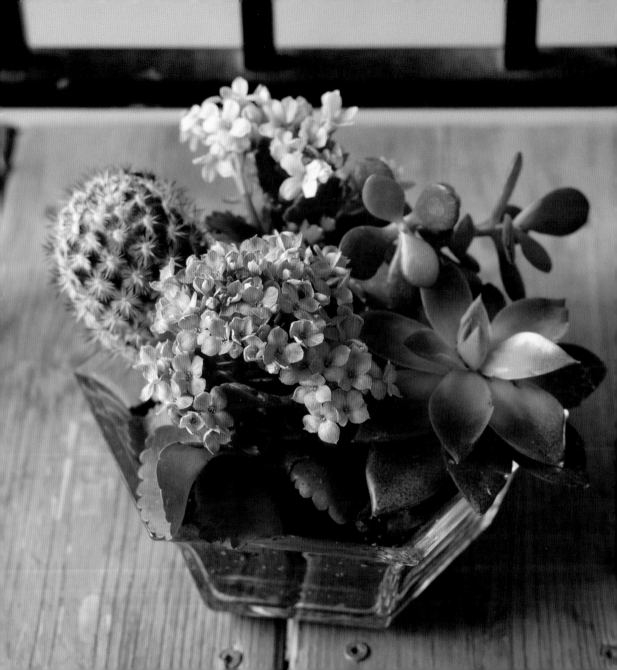

Pretty in Pink . . . and Yellow!

A colorful but simple glass garden. Pinks and yellows in a sea of succulents reminded me of spring!

WHAT YOU'LL NEED:

Glass bowl or shallow dish | Stones | Charcoal | Soil | Terrarium tools | Mix of plants (succulents, cacti, and tropical plants)

PUTTING IT ALL TOGETHER:

In the interest of not repeating the same thing over and over, let's assume you've done the first couple of steps already and prepared your container (clean, dry, big three).

I saw the vibrant colors of these flowering kalanchoe plants and picked them up immediately. I don't usually use flowering plants, but there was something so Spring-like about them. I paired them with a large hen and chicks succulent (that's the one that looks like a big green flower) and a jade plant. I arranged them in the glass bowl

Continued on page 86

. . . and then moved them around. I tried again, but no matter how I grouped them together, there was something missing. I finally grabbed a little cactus I had lying around and popped it into the arrangement. It filled that empty spot perfectly and added a little bit of texture to the garden.

Beautiful colors, glossy greens, and a little bit of texture. That's all you need!

Purple Reign

An eye-catching arrangement in shades of purple that will brighten up any room and would make an excellent gift for anyone who needs a pick-me-up. An absolute symphony of purple.

WHAT YOU'LL NEED:

Glass, china, or porcelain container | Stones | Charcoal | Soil | Terrarium tools | Tropical plants | Glass pieces | Figurine of your choice

PUTTING IT ALL TOGETHER:

Prepare your container as usual, washing it and adding stones, charcoal, and soil. I found a gorgeous flower pot at a thrift shop that I grabbed without knowing for sure what I was going to do with it. I was swept away by the purple in this container so I wanted to find plants to really compliment it—not just in shades of green but with hints of purple, as well. With that in mind, I went shopping. (The best part of creating a glass garden!)

I settled on two plants that I thought would fit well in the container and give the arrangement that splash of color I was looking for: a *Tradescantia spathacea*, or Moses

Continued on page 89

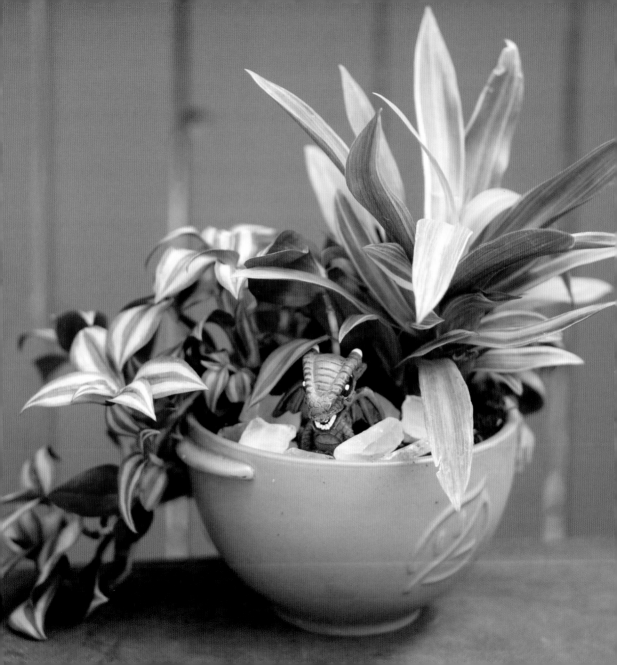

in a cradle, and a plant called a Wandering Jew. The Moses in a cradle has green variegated leaves which have a deep purple underside that I thought was stunning, and it had enough height to keep my glass garden interesting. With the height taken care of, I looked for a trailing plant with some color and came up with the Wandering Jew. It has variegated leaves like the *Tradescantia* with a slightly darker purple underneath. They were perfect together!

Once you've selected your plants, place them. Play around with the arrangement until you get it right. You can leave a spot open for a figurine—I chose a dragon—or fill it with another plant. As always, you make the rules.

Sprinkle some glass pieces around the top and you're finished!

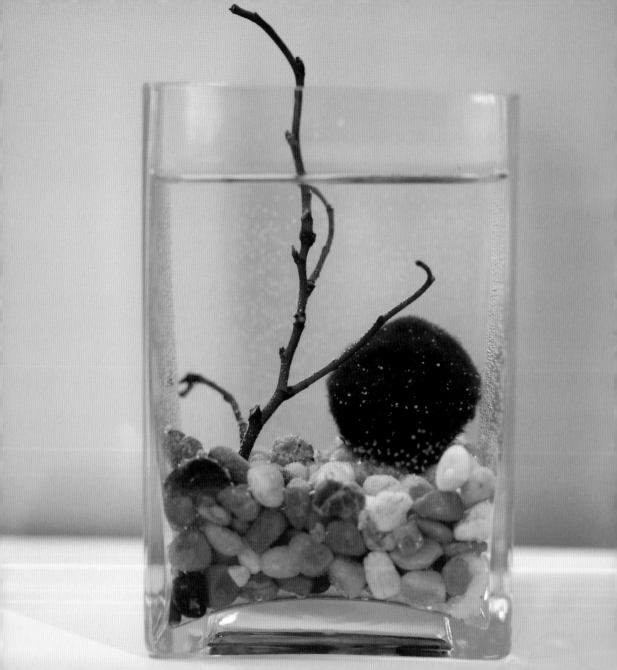

River Moss (Ball)

Stones worn smooth by the water sat on the bottom, branches poked up out of the water, and while I didn't see any moss balls down there, I did see all kinds of water plants floating in the current. This water terrarium reminded me of a riverbed back home.

WHAT YOU'LL NEED:

Glass container | Marimo Moss Ball(s) | Smooth stones | A twig | Water

PUTTING IT ALL TOGETHER:

Clean your glass and dry it well. I'm sure you can buy a twig or branch somewhere, but I just walked into my backyard and clipped one off a tree. I placed it in the bottom and played with it a bit, moving it around until I liked the effect. I held it carefully in place and poured my stones around it to stabilize it. I poured water in and then added the moss ball.

As always, top off your water when it starts to evaporate, but otherwise, you should be able to just leave your moss ball alone.

TIP! Marimo Moss Balls are sold at aquarium and pet stores. Don't be fooled by moss balls you can find at craft stores—those are just Styrofoam balls covered in preserved moss.

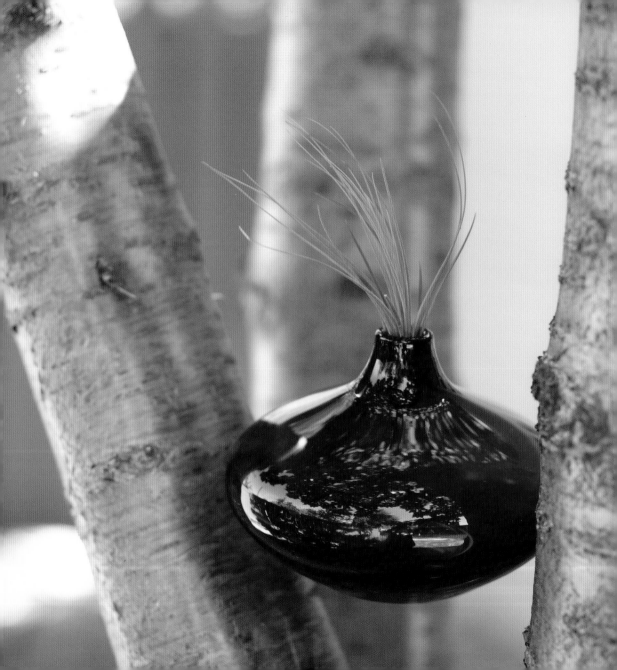

Ruby Red

Another effortless way to display an air plant, not to mention a beautiful way to show off a unique piece of glassware.

WHAT YOU'LL NEED:

Piece of glassware with a small neck | Small air plant

PUTTING IT ALL TOGETHER:

Craft stores. Kitchen stores. Home décor shops. Thrift stores. I've hit them all looking for unique glass containers. I found this one with its narrow neck and had no idea what I was going to do with it, but I loved the color so much that I had to bring it home. It sat on my workspace for a while with the sun shining through it until I finally stopped stressing out about how to plant something inside. I grabbed an air plant and plugged it into the neck of the container, and *voila*! Simple as that. It's still sitting on my kitchen counter, catching the sun.

Oh—and don't forget to clean your container first.

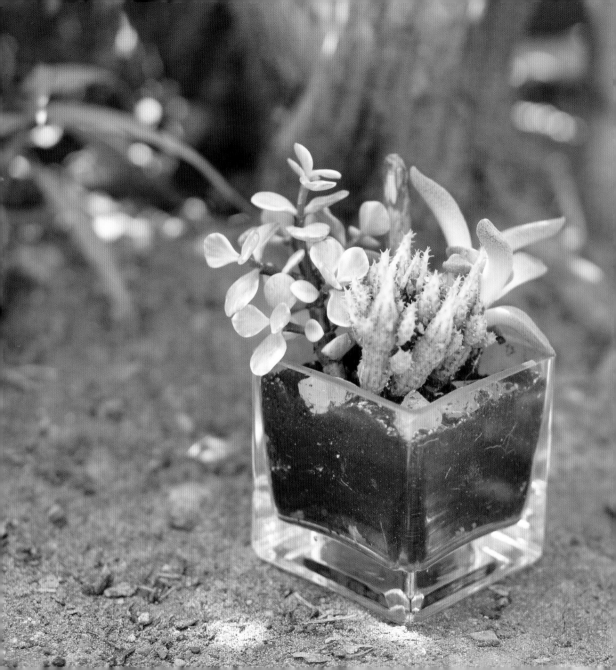

Sticks and Stones

An uncomplicated terrarium of light greens with touches of red and brown.

WHAT YOU'LL NEED:

Glass container | Stones | Charcoal | Soil | Terrarium tools | Assortment of succulents | Glass pieces or stones | Sticks or other decoration

PUTTING IT ALL TOGETHER:

I had a little square glass container that I was dying to use but needed plants small enough to fit. I found a bunch of assorted succulents—unlabeled, as usual—that weren't even in pots and picked up ten or so.

Prepare your container by washing it and filling it with stones, charcoal, and soil. This one is simple. Just add your plants, moving them around, exchanging them for others— keep working at it until you get it right. I used a *Crassula portulacaria afra* with round green leaves and red stems and a couple of other succulents that came unnamed and that I haven't been able to identify. Truthfully, it has never mattered much to me what they were called; I just pick them because I like the way they look. I added the stick to finish it off.

Continued on page 96

TIP! You can use virtually anything to decorate a terrarium. I found this stick on the beach and kept it. It had been worn smooth from being tossed against the shore and there was something I liked about it. Whenever I feel like something is missing, I grab a bunch of random odds and ends and start adding them to the arrangement until I figure out what works. Anything goes!

Tea for Two

I grew up with a Scottish grandmother who loved her tea. She would have wholeheartedly approved of these glass gardens. Two delicate, whimsical decorations for your table. Perfect for a shower or dinner party. In fact, you could use the larger teacup as a centerpiece and give smaller versions away to your guests. It's just as ladylike as my Scottish granny would want it to be.

WHAT YOU'LL NEED:

Cup and saucer pairing | Giant teacup | Stones | Charcoal | Soil | Terrarium tools | Small succulent, such as haworthia) | Tropical plants | Figurine of choice, such as an elf or fairy | Decorative Stones | Preserved moss

PUTTING IT ALL TOGETHER:

For the smaller option, you can either use a novelty cup and saucer planter, which you may find at a local nursery, or a vintage cup and saucer set that you have on hand or have picked up for a couple of dollars at a secondhand store.

As always, clean your teacup inside and out and start with the big three—stones, charcoal, and soil. You'll want to find a succulent that you can center in the cup that's

Continued on page 99

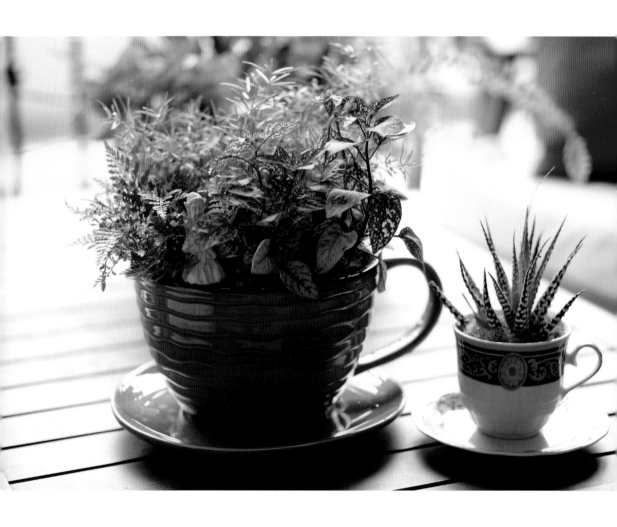

the right size so the plant doesn't overpower the container. Plant your succulent and finish by surrounding it with preserved moss.

For your giant teacup, clean your container and start with your big three—stones, charcoal, soil. Then it's really up to you. I chose tropical plants for mine. I wanted something that would spread out enough to fill up the pot but blend together into a bit of a jungle. Use ferns to give it a wild look. I also chose a polka dot plant to add some color.

Place your plants around the outside of your planter—or inside, if you can fit them—so you can get an idea of where you want them to go. Gently remove your plants from their pots and take the excess soil off the roots. Some of mine got pretty dry, so I soaked the roots a bit before I planted them in the tea cup. If your placement doesn't look right, then move things around. Once you've got everything planted to your satisfaction, sprinkle some decorative stones around the base of your plants to tidy it all up and give it a more finished look. I used pieces of polished glass in mine, but anything could work. If you don't like the look of stones, you can use preserved moss. You can finish up with a figurine or two, depending on how large your teacup is, or leave it just the way it is.

Terraria

A classic closed terrarium full of beautiful succulents.

WHAT YOU'LL NEED:

Closed terrarium | Stones | Charcoal | Soil | Terrarium tools | Succulents and cacti | Smooth stones, for decoration

PUTTING IT ALL TOGETHER:

Prepare your terrarium glass by cleaning it thoroughly, allowing it to dry, and then placing the big three—stones, charcoal, and soil. When choosing your plants for this project, you can choose whichever you like best. I used a few I had around—I'm not even sure what one of them is called! (Surprised? Don't be. We know each other well enough by now.) Whatever you have on hand or find when you're out at the nursery will work.

I used a little cactus and then a variegated aloe of some sort that had some height to it, thanks to a stem that grew out of the middle. I still had some space so I added an odd little cactus that I had picked up somewhere or another. I spaced them out evenly and then spread a layer of stones on the bottom. Simple, but stunning. The hardest part

Continued on page 102

was getting soil out of the cactus! It's tricky, but my kids' paintbrush came in handy yet again. Depending on the type of cactus you're using, you might not be able to get all of the soil off easily. Try using the other end of the brush and tapping it gently to loosen the dirt. Then just brush it away.

TIP! You can fill up as much space as you like or just focus on a few plants like I did. Succulents prefer to have some space around them.

Texture, Texture, Texture

A simple green terrarium with wildly varying shades and textures and just a bit of added glitz.

WHAT YOU'LL NEED:

Container | Soil | Charcoal | Stones | Terrarium tools | Assorted succulents (I used a jade plant, a chalk sticks succulent, a santalina, and a cactus) | Crystals or other stones, for decoration

PUTTING IT ALL TOGETHER:

Like every other terrarium (except air or water plants), always start with a layer of stones for draining and charcoal to avoid any root rot. I added a few inches of soil and was ready to go.

Start by arranging your plants around the outside of your container so you can get an idea of where you want them placed. You'll likely end up moving them around even after you plant them—I always do—but it will give you a starting point.

Continued on page 105

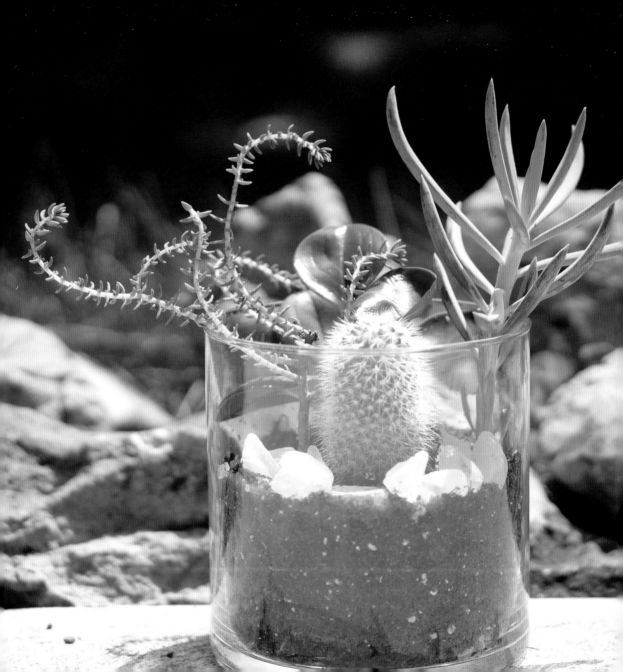

To take your plants out of their plastic containers, gently squeeze the sides until they loosen and slide out easily. Once you have your plants free, you can clean up the roots by brushing all the extra soil loose and leaving the roots exposed. If your plant is too dry, let the roots soak for a bit.

Once your plants are ready, use your spoon to dig a hole big enough to hold your first plant. This is the easiest part because you'll be working around this one. Place your plant carefully and push the soil down around the roots to stabilize it.

Now it gets a little trickier. You're going to do the exact same thing with the next plant, but as you'll see, you're going to end up moving them around after you plant them. I can't speak for anyone else, but I never get it exactly right the first time. I moved the plant on the left twice before it looked right. This is all about trial and error, and that's absolutely okay. You'll want different heights, and one plant might not look right beside the other. So you move them. No big deal.

The last thing I did was place the cactus. Although I love the way they look, I absolutely hate working with cacti because I'm a bit of a klutz and I inevitably skewer myself while planting them. I've seen better gardeners than me place them easily, sometimes using tools to help, but the only way I can get a cactus planted properly is by hand. My big goal when planting a cactus is to get it placed absolutely perfectly the first time so I don't have to move it.

That almost never happens.

Continued on page 106

In this case, I had to move the cactus three times, stabbing myself repeatedly and ending up with a cactus splinter embedded deeply in my finger that was somehow completely invisible to the human eye. I wish this on no one—but it may happen to you, so be careful!

Once you have all your succulents planted perfectly, add some extra soil and tamp it down around the base of your plants. Use your paintbrush to get rid of all the soil that's stuck to your plants.

The last step for this one was to add some amazing polished stones or crystals around the base of the plants. I found these at a nursery and loved the way they finished my terrarium.

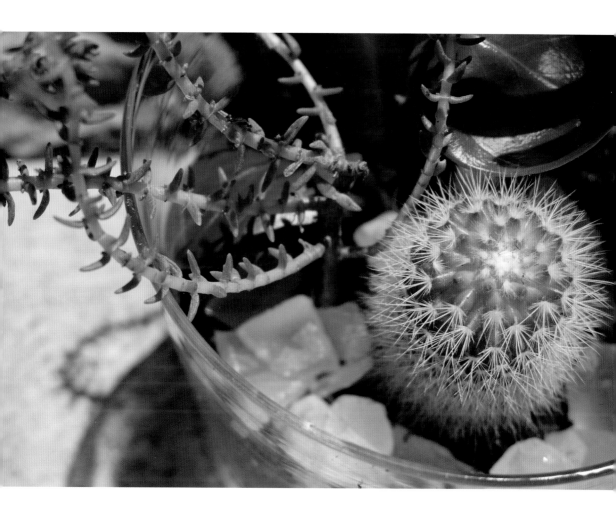

Under Glass

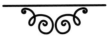

A living piece of jewelry reminiscent of *Beauty and the Beast*. Wearable art with just a little bit of magic.

WHAT YOU'LL NEED:

Cloche that has a loop for a chain or cord | Cord or chain | Air plant | Decorative glass (optional) | Preserved moss (optional) | Pebbles (optional)

PUTTING IT ALL TOGETHER:

First step, as always, is to clean the glass well, inside and out. They're very delicate so dry them carefully. You'll need to put the air plant into the top, or the cloche. You can leave the bottom empty or sprinkle bits of decorative glass inside. You can put a piece of preserved moss in the bottom or use tiny pebbles. Anything you think will work. You can always switch it out later because you won't be able to seal your glass garden.

Put the top and bottom together and put a slight amount of pressure around the edges to seal them. Again, be careful not to break the glass. You won't be able to glue this one or the air plant will die. Just open it up every week or two and soak your plant to keep it healthy.

 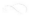

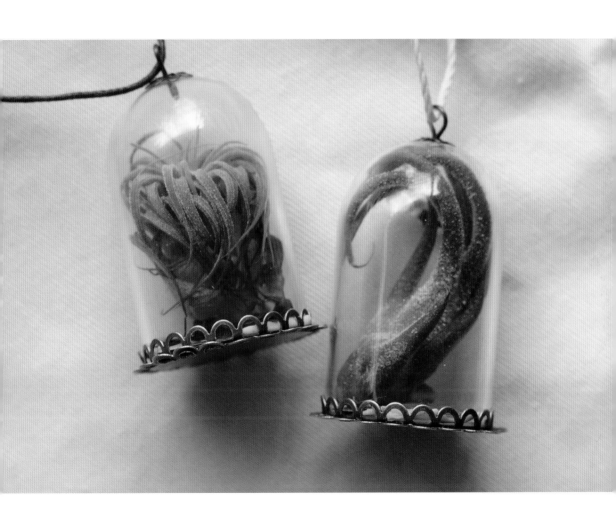

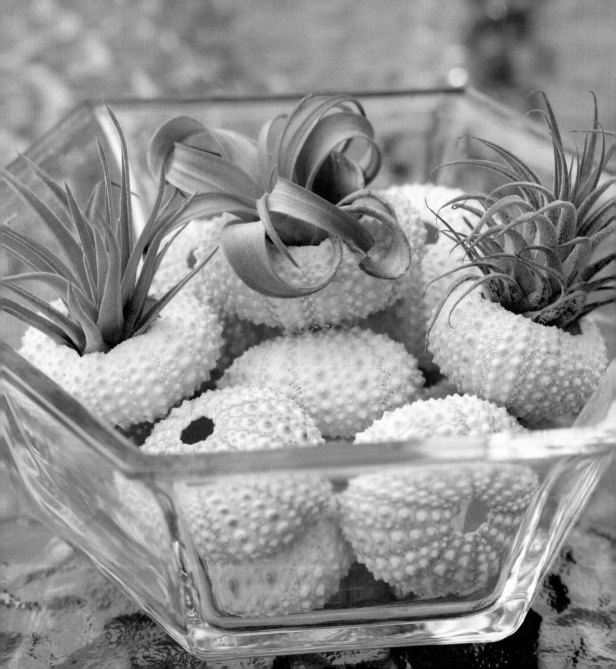

Urchin Glad You Thought of This?

A pretty, unique piece that would make a great centerpiece. Depending on what color sea urchins you can find, you can match pretty much any type of existing décor.

WHAT YOU'LL NEED:

Glass bowl | Sea urchin shells/skeletons | Air plants, different varieties and sizes

PUTTING IT ALL TOGETHER:

Like most air plant projects, this one is pretty effortless. Place an air plant in the bigger hole in your sea urchin shell. And . . . that's it. No, really. I picked a glass bowl and layered different shades of the urchin shells in the bottom and then played around with the placement of the air plants.

Keep in mind that the urchin shells are pretty delicate and will break easily so handle them with care.

TIP! Always keep in mind that you can use virtually anything for your garden. Once in a while, venture away from the standard glass containers (I know, I know—you're holding a book titled *Glass Gardens*) and look for unusual places to display your plants.

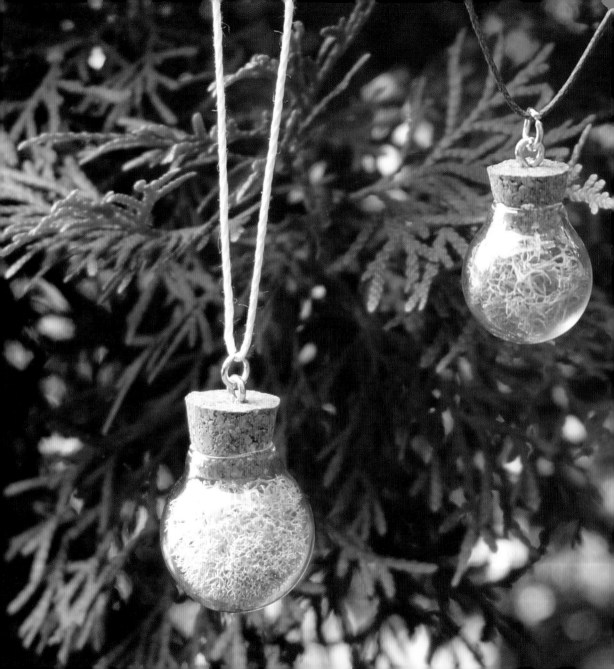

Vials

The *Glass Garden* accessory collection gets even simpler with just a bit of moss and a vial.

WHAT YOU'LL NEED:

Vial with a twist off or cork top | Chain or cord | Preserved moss

PUTTING IT ALL TOGETHER:

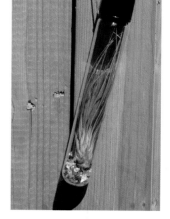

This is an excellent project to do with kids since it's pretty foolproof. I found some cool little vials at Michael's Craft Stores, but shop around and see what you can come up with. I also found one that was like a test tube with a screw cap that I tied some cord to, but I think it would also make a pretty cool decoration if you glued them to a frame. (Note to self: Try that!)

Just take the top off your vial and fill it with preserved moss. Since you don't need to worry about watering it, you can cap the vial and even glue it closed if you want. I had white and green moss on hand, but you can use anything from purple to blue for yours. Match your cord to the moss color, if you want. You can wear this around your neck, or hang it somewhere in your home.

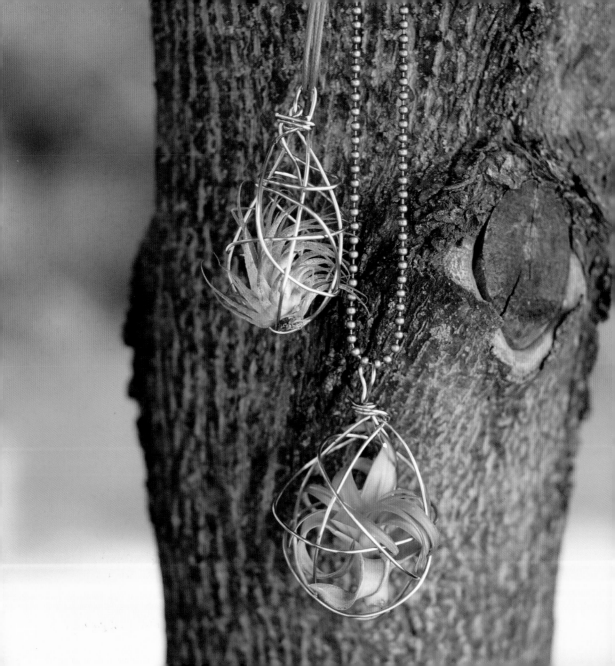

Wired

A cool, funky piece of living jewelry that will make people stop and notice you.

WHAT YOU'LL NEED:

Wire (18–20 gauge) | Wire cutters | Needle-nosed pliers | Chain or ribbon | Sizeable air plant

PUTTING IT ALL TOGETHER:

I cannot possibly explain how much I love this project! There's almost nothing cooler than a piece of wearable art, and I can honestly say that it's extremely unlikely you will ever run into anyone else wearing anything quite like this piece.

This one is going to take some trial and error, though. I think I had two failed attempts before I finally figured out what I was doing and got it right. It seems fairly easy—wrapping wire around and around into an empty sphere—but don't be fooled. If your wire is too soft, it'll collapse into itself and, until you get the hang of it, it can be harder than you think to get a good shape that will hold your air plant. Make sure you buy enough wire to do a few practice runs with. You can find jewelry wire at craft stores.

Continued on page 116

You'll want to use a gauge of wire that's soft enough to manipulate but hard enough to hold its shape. Try 18 or 20 gauge wire.

Form a u-shape with your wire and twist it around into another u, basically making an egg-shaped sphere. This is the base of your jewelry. There's no hard and fast rule with this. Like most terrariums, it's really about how you want it to look. Just loop it around and cross it over itself until it looks how you want it to look.

You'll need to make a loop at the top, and the best way to do this is while you're still working on your piece and not when you're finished. Just leave a longer loop at the top and keep going. You can finish it by wrapping your loose ends around it—both the one you started with and the one you end with. Use your pliers to weave it in tightly.

You'll also need to leave enough space somewhere to insert your air plant and take it back out to water it.

Practice really does make perfect with this one. It may seem complicated at first, but as soon as you start playing around with the wire, you'll see that it's much easier than it looks. When you're finished, you'll have a one-of-a-kind piece of statement jewelry that everyone will be asking you about.

TIP! Experiment with different gauges of wire until you have one you can easily work with but that holds its shape when you're finished.

Conclusion

I have to be honest: a lot of plants died in the making of this book. I'm only half joking. I did lose a couple, and you very well may lose some, too. But please don't let that stop you from trying. There's a lot of trial and error, and that's okay! Don't be afraid to get your hands dirty. Or your counter. Or your floor. Unless you're some kind of plant whisperer, you're going to make mistakes, just like me. You might even finish a project and hate it. If that happens, take it apart and try again. Keep trying until you think it's right. Make mistakes. Make a mess. And ultimately, make something beautiful.

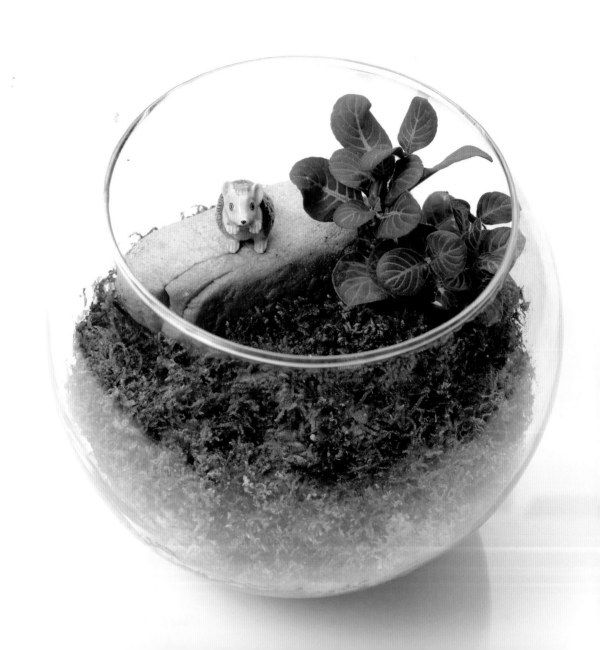

Popular Plants to Try

There are literally hundreds of plants you can use in your terrariums, but some are easier to work with than others.

- Succulents! Succulents are the easiest plants to work with because they're extremely hardy and don't require too much attention. Some of my favorites are aloe, moon cacti, haworthias, and sempervivums like hens and chicks. I've found them to be extremely easy to keep healthy and thriving.

- Ferns are also great choices for terrariums. Bird's nest fern, button fern, and maidenhair fern are the ones I've worked with the most, and I love the way they look.

- Different types of moss, like club moss and spike moss, are easy to grow, but if you want to avoid live moss, you can easily use preserved moss in your terrariums.

- I've used lots of tropical plants and can highly recommend Moses in a cradle, pink polka dot plants, and spider plants.

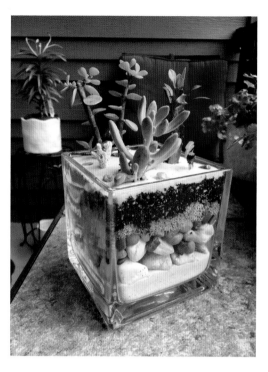

- You may find it hard to get a good variety of water plants, so ask your local pet store or aquarium what will work best for the water terrarium you're planning. Moss balls are the easiest to work with, and I've had great luck with anubias plants. You can also ask at your local nursery if any of their plants would work in water.

- And, of course, air plants. Tillandsias come in all shapes and sizes, so choose your favorites and go from there.

Notes

Feel free to record your own ideas on the pages that follow.

About the Author

Melanie Florence is an award-winning author who has written everything from picture books to young adult novels, nonfiction books, and magazine articles for international publications. Her first picture book, *Missing Nimama*, won the 2016 TD Canadian Children's Literature Award and a Notable Books for a Global Society Award. Melanie currently lives in Toronto with her family. Find her online at www.melanieflorence.com.